IMAGES
of America

POINT LOMA

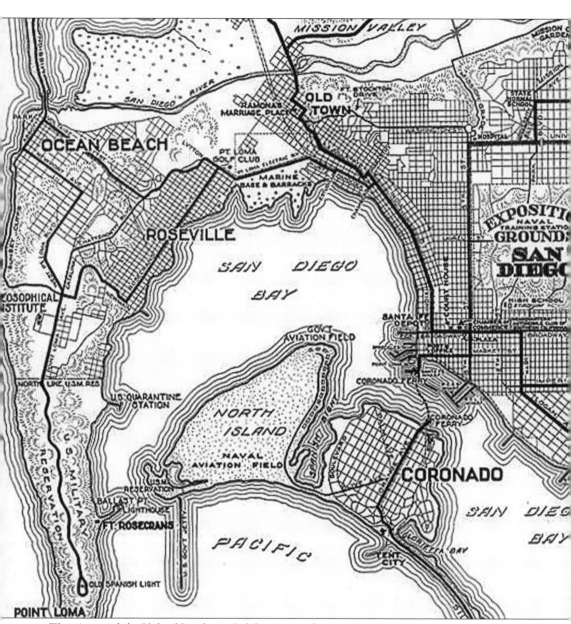

This Automobile Club of Southern California map from 1918 may serve to give our reader a good idea of Point Loma's location relative to downtown San Diego, San Diego Bay, Coronado, and Old Town. Clearly indicated are places we discuss in this book, such as Ballast Point, Roseville, Point Loma Lighthouse (noted as Old Spanish Light), and Fort Rosecrans. Several other locales, such as the Theosophical Institute, the Quarantine Station, and the Point Loma Golf Club remain with us only as memories. (Automobile Club of Southern California, public domain.)

ON THE COVER: Pictured is the start of the Eighth Biennial San Diego to Acapulco Race on January 30, 1966. The boat in the foreground is Jim Kilroy's *Kialoa II*. (Courtesy of the *San Diego Union*.)

IMAGES
of America

POINT LOMA

La Playa Trail Association

ARCADIA
PUBLISHING

Copyright © 2016 by La Playa Trail Association
ISBN 978-1-4671-1735-7

Published by Arcadia Publishing
Charleston, South Carolina

Printed in the United States of America

Library of Congress Control Number: 2016941982

For all general information, please contact Arcadia Publishing:
Telephone 843-853-2070
Fax 843-853-0044
E-mail sales@arcadiapublishing.com
For customer service and orders:
Toll-Free 1-888-313-2665

Visit us on the Internet at www.arcadiapublishing.com

*To the Native Americans, traders and trappers, priests
and soldiers, ranchers, merchants, adventurers, and
explorers who have walked the La Playa Trail*

CONTENTS

Mary Ann's Tales of our past. XY Gina

ACKNOWLEDGMENTS

Putting this book together has been a group effort. La Playa Trail Association would like to thank the many individuals and organizations who lent their time, talents, energy, and expertise to the production of this volume. In particular, we would like to thank current members of La Playa Trail Association Board, including Patti Adams, Charles Best, Virginia Correia, Eric DuVall, Barbara Franklin, Joanne Hickey, Bill Kettenburg, Klonie Kunzel, Kitty McDaniel, Karen Scanlon, Carl Shipek, and Ed Streicher. In addition, Linda Fox, Rick Kennedy, Alan Ziter, Iris Engstrand, Linda Canada, Dorothea Laub, Kerri De Rosier, Stuart Hartley, Don Szalay, Joe Janesic, and Robert Jackson have been instrumental in the creation of our book.

We would also like to sincerely thank the Point Loma Assembly, Jim Baker, Barbara Busch, Cecilia Carrick, Kim Fahlen, James Phelan, Tom Shjarback, the County of San Diego, Chris Travers, Carol Myers and Matthew Schiff of the San Diego History Center, and Conrad Wear of the Office of San Diego City Councilwoman Lorie Zapf. Additionally, we owe a debt of gratitude to Linda Hasper of Point Loma Nazarene University, Jesus Benayas of the House of Spain, Morgan Hansen and Allen Wynan of the University of San Diego, Randall Grubb of the Theosophical Society–Pasadena, Mary Allely of the Ocean Beach Historical Society, Ken Small of the Point Loma School of Theosophy, Tom La Puzza and Kelly McKeever of SPAWARSYSCEN-PACIFIC, the Point Loma Association, the Point Loma Foundation, and the Point Loma High School Alumni Association. Many of the photographs in this book are used courtesy of the San Diego History Center (SDHC) and the San Diego Yacht Club (SDYC).

INTRODUCTION

The founding and early development of San Diego is a product of Point Loma's distinctive geography. Point Loma became a point some 7,000 to 9,000 years ago, when the sea level rose more than 300 feet, filling in around its base and creating San Diego Bay. Most of the point rises another 400 feet above sea level and blocks the bay from the prevailing northwest winds. During the great age of exploration in the late 1500s, sailors began using the name La Punta de la Loma (the Point of the Hill) to describe this prominent feature of the eastern Pacific Ocean where ships could be safely anchored year-round. Before trains, planes, and automobiles, a great city would usually grow where there was an excellent point combined with a good anchorage. In later years, Point Loma's geographical position jutting out into the Pacific encouraged its development as a distinctive community within San Diego, first as a multiethnic fishing and whaling community and later as a Theosophical utopian colony, a strategic military complex, a leading center of oceanographic research, and a world-class destination for deep-sea fishing and sailboat racing.

Like many coastal communities, Point Loma has attracted a unique collection of people and institutions. Those who want to understand the human history of Point Loma do best to think in four layers: Indian settlements; the Spanish Empire; Mexican nation-building; and Point Loma's strategic location. The first known human settlement, or at least campsite, on Point Loma was at Ballast Point around 10,000 years ago, even before the waters of the bay filled in. Archaeological remains indicate that shark fishing was a draw to the site far out on the point. About 1,200 years ago, the Yuman-speaking ancestors of both the Ipai and Tipai (Kumeyaay/Diegueño) began settling along the San Diego River, and about 700 years ago, the Ipai settled onto the point in two villages, one at what is now the Naval Training Center and one at Ballast Point.

The second layer of history is the reign from 1542 and 1821 of the Spanish Empire, the world's most extensive and highly developed empire during that time. In the name of conquest, many evils were perpetrated upon indigenous populations by Spaniards, but the empire's intentions—especially relating to the Californias—were benign. The newest and best scholarship on the empire, including standard textbooks such as John L. Kessell's *Spain in the Southwest: A Narrative History of Colonial New Mexico, Arizona, Texas, and California* (University of Oklahoma Press, 2002), emphasizes this point. When global strategists in Spain studied their maps of the world, they discussed plans for Point Loma and its bay. In the late 1680s, Jesuit missionaries had already begun creating utopian-style Jesuit-Indian settlements in Baja California, funded by a special church endowment called the Pious Fund for the Californias. José de Gálvez, representing the Spanish king, was sent to Baja California to remove the Jesuits. He replaced them with Franciscans and orchestrated the placement of a mission and a presidio (fortress) at both San Diego and Monterey, two bays in California that had long been names on maps but had not yet been settled. In the late 1760s, the Spanish were worried about the movements of the Russians, British, French, and Dutch in the Pacific Ocean, and the Spaniards eventually built a small fort on Ballast Point to guard the entrance to the bay.

The Spaniards wanted to protect their interest in San Diego Bay, but at the same time, they aspired to benevolence—not violence. Friendship with the Indians was their first goal; creating a homogenous Christian society was their ultimate goal. Indians, it was hoped, would retain much of their land and share in an interracial society as citizens. However, diseases and the steady stream of newcomers resulted in different settlement patterns, and the Indians ultimately lost their claim to Point Loma.

After the Indian and Spanish layers of Point Loma history, an independent Mexico claimed the point. Mexico allowed foreign fur traders to settle along La Playa at the base of Point Loma behind Ballast Point. An old Indian trail became a stable trade route between the anchorage and what is now called San Diego's Old Town. What was called the La Playa Trail, the oldest continually used road in California, eventually became Rosecrans Street. Also during this Mexican layer of Point Loma's history, one of the great books of American literature, *Two Years Before the Mast*, was written by Richard Henry Dana, a young man on break from Harvard hoping to find health and adventure at sea. Dana lived on Point Loma for six months out of the two years he traveled, from 1835 to 1836, and later wrote some of his most vivid stories about his life there.

The fourth layer is Point Loma's distinction as the southwesternmost reach of the continental United States. The ambitious leaders of the young United States wanted ports on the Pacific Ocean, and it is no stretch of the imagination to picture Thomas Jefferson, James Madison, John Quincy Adams, and Andrew Jackson in Washington, DC, leaning over maps of California discussing the strategic importance of Point Loma. They might have hoped to get Mexico's province without a war, but when the war came, one of the first duties of the US military was to secure Ballast Point and the southern end of Point Loma.

Given its four layers, Point Loma has as deep a history as any place on the East Coast. What makes Point Loma distinctive is the theme of peace, fellowship, and healthy living that has largely characterized the different layers of its history. The Indians long tried to cultivate these characteristics, and the Spaniards arrived with peaceful intentions and used the point to mark the gateway to San Diego. During the Mexican period, one of the most heartening events of California history occurred on Point Loma in 1836, when, as Richard Henry Dana tells us, a motley bunch—multinational, multiethnic, and multilingual—joined together to sing each other's national anthems around a campfire on La Playa. Some 70 years later, up the hill from the beach at the Theosophical Society colony, a cohort of Point Loma residents organized an international peace conference. These themes provide an interesting backdrop to Point Loma's parallel history as a place of geopolitical military strategy and the site of a cemetery dedicated to the nation's war dead. Indeed, Point Loma's history is deep as the waters surrounding our beloved point and varied as the people who have claimed it as their own.

One

Beginnings on Ballast Point and La Playa

Early in March 1835, Richard Henry Dana Jr. rounded Point Loma, squeezed past Ballast Point, and anchored off La Playa. In *Two Years Before the Mast*, Dana describes Point Loma as a "chain of high hills," Ballast Point as "a low stony point," and La Playa as a "smooth sand beach." Coming south from Monterey, Santa Barbara's surf was a struggle, San Pedro was depressing, San Juan Capistrano (now called Dana Point) was risky, but Dana describes La Playa on Point Loma Dana as "a snug little place, seeming quite like home."

Before the 1860s, San Diego was hard to get to by land, and most people arrived by the same process as Dana: sail round Point Loma, avoid Ballast Point, and anchor at La Playa. La Playa Trail, now called Rosecrans Street, would then take them into the small presidio town.

Indians had long lived at La Playa, and fresh water was readily available. There is evidence of a spring that flowed down onto La Playa roughly where Kellogg Street is today. Florence Shipek, a Point Loma resident and an important anthropologist studying Southern California Indian history, believed that two plants still found today in the area, the lemonade berry and the prickly pear bush, were first transplanted by the Kumeyaay several hundred years before the Spaniards arrived as a supplement to the fish and lobsters easily available along the beach. Nature was good to these earliest residents of Point Loma. In *Two Years Before the Mast*, Dana writes that one of the amusements at La Playa was called "burning the water" for crawfish. In a small skiff, with one man steering, another holding a torch at the bow, and one on each side with harpoon-like sticks, Dana and his friends would fish for dinner. "The craw-fish are an easy prey," he observes, "and we used soon to get a load of them."

La Playa offered a pleasant, protected beach, and has remained primarily residential, while Ballast Point became an internationally strategic landing place.

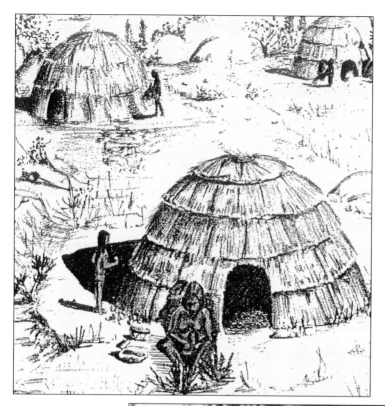

The Ipai, the northern division of the Kumeyaay, developed a village, or at least a seasonal settlement, on Ballast Point hundreds of years before the Spaniards arrived. This image depicts what would have been the first known form of domestic architecture in Point Loma. (Sketch by William Crocker.)

Listening to the Kumeyaay pass on their memories is important for understanding Point Loma's earliest history. Here, in the late 1960s, Dephina Cuero identifies plants cultivated by the Kumeyaay. Pictured, from left to right, are helper Rosalee Robinson, Cuero, an unidentified ranger, Point Loma resident and anthropologist Dr. Florence Shipek, and linguist Dr. Margaret Langdon. (Courtesy of Carl Shipek.)

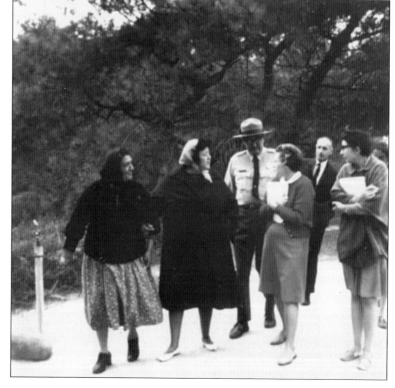

For over 50 years, the Cabrillo Festival has celebrated the landing of Juan Rodriguez Cabrillo at Ballast Point on September 28, 1542. San Diego was heavily populated by the Kumeyaay, and Indians initially wounded three of Cabrillo's men. Cabrillo, however, did not retaliate and was able to establish better relations before leaving five days later. (Courtesy of Cabrillo National Monument.)

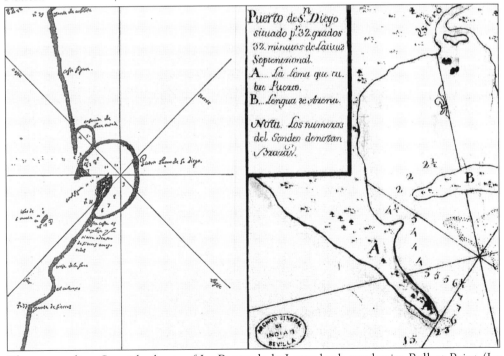

The two earliest Spanish charts of La Punta de la Loma both emphasize Ballast Point (La Punta de los Guijarros) and the anchorage behind it at La Playa. The sketch on the left is from the Sebastián Vizcaíno expedition of 1602, and the chart on the right was drawn at the time of Spanish settlement of San Diego in 1769. (Left, courtesy of the Archivo General de Indias, Sevilla, Spain; right, public domain.)

Mexican Point Loma burst into the literary world in 1840 with the nonfiction best seller *Two Years Before the Mast*. Considered a classic of American history and maritime literature, the book is an account of young Richard Henry Dana's trip from Boston to California and back. Significant portions of the book take place at La Playa, where he lived for six months in 1835–1836. At La Playa, Dana befriended a colony of Hawaiians who were living in an adobe igloo previously abandoned by Russians. Dana writes that La Playa was the headquarters for all the Hawaiians on the coast of California. Life on La Playa was happy: workers in the hide barns owned by shipping companies were productive; and evenings were full of multiethnic, multilingual, and multinational camaraderie. Dana spent his last night in California with the Hawaiians in their "Kanaka Hotel" on La Playa. (Courtesy of the National Park Service, Longfellow House–Washington Headquarters National Historic Site.)

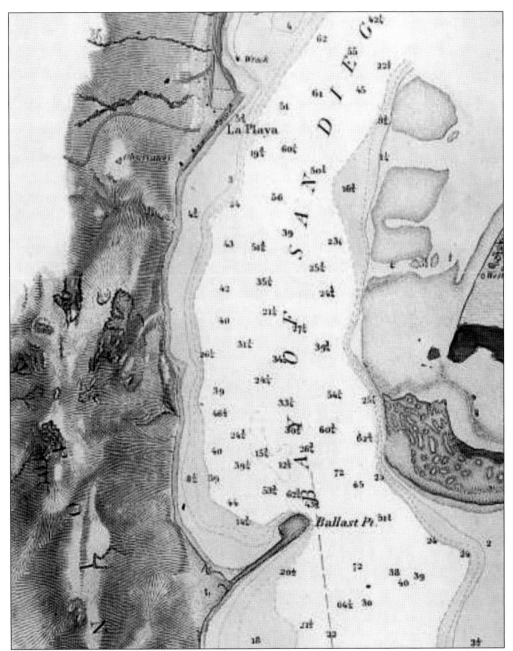

Ballast Point and La Playa are clearly marked on this 1853 US Coast Survey chart of Point Loma and the entrance to San Diego Bay. The small dots along La Playa mark the hide houses, Point Loma's earliest permanent housing. Dana describes the pleasant life of a multilingual community in 1836 that included 20 Italians, a dozen or more Hawaiians, a dozen Mexicans, various numbers of Englishmen, Yankees, Scotsmen, Welshmen, Frenchmen, Spaniards, Chileans, Kumeyaay Indians, and "one Negro, one Mulatto . . . one Otaheitan, and one Kanaka from the Marquesas Islands." The "Sailing Directions" on the chart recommend what had been the traditional way to arrive in San Diego since 1542: sail past Ballast Point and "steer direct for the Playa and anchor as you please." (Courtesy of the National Oceanic and Atmospheric Administration.)

The diverse community lived in the barns and barracks at La Playa from the 1820s into the 1850s. This drawing by William H. Meyers was done from the deck of the USS *Cyane* during the United States' war with Mexico. (Courtesy of the Bancroft Library, University of California, Berkeley.)

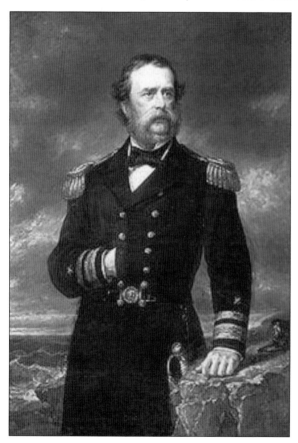

Comdr. Samuel Francis Du Pont landed at La Playa on July 29, 1846, and marched with his men to Old Town, capturing it without a fight. When the war ended in California in January, he hosted a peace celebration at La Playa. He said, "They were so kind to us last summer when we first took possession here, and since our arrival, that I have long wanted to pay them some civility." (Courtesy of the National Portrait Gallery, Washington, DC.)

Lt. James Madison Alden Jr., who was often in and out of La Playa in the 1850s, headed the hydrography portion of the US Coast Survey, which was responsible for supplying all information for navigation, including underwater hazards and tide patterns. Highly experienced, Alden had been a key leader of the US Navy's expedition to Antarctica and went on to command ships for the North in the Civil War, eventually becoming an admiral. (Courtesy of the National Oceanic and Atmospheric Administration.)

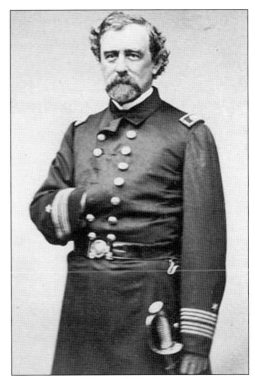

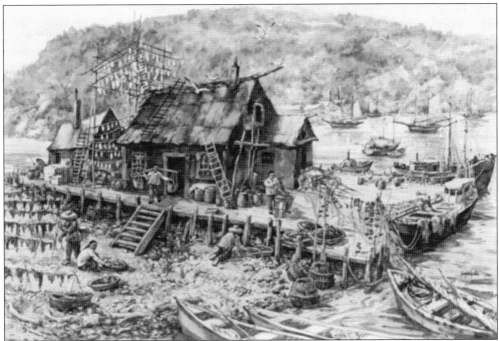

After the Mexican fort was abandoned in 1846, a multiethnic residential community began to form on Ballast Point. Depicted here is the Chinese fishing station. Whalers also had a base close by. Peaceful and productive relations existed here and at La Playa for decades. (Painting by Jay Wegter, courtesy of House of Spain, San Diego.)

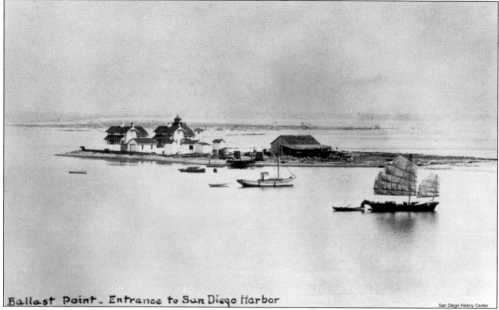

Ballast Point. Entrance to San Diego Harbor

San Diego History Center

In 1872, the US military reclaimed Ballast Point for a lighthouse and other purposes. Both the whalers and the Chinese relocated their businesses up the beach to La Playa cove, where the Chinese expanded into shipbuilding. In this c. 1920 photograph, the Chinese junk *Hazel*, captained by an elderly Chinese man, anchors behind Ballast Point. (SDHC.)

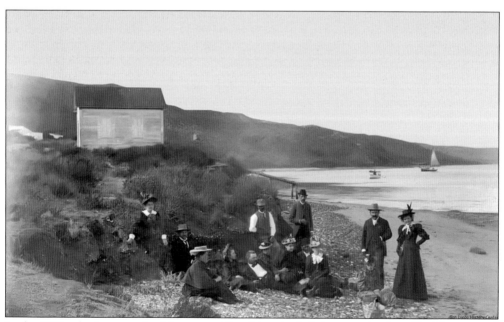

In the 1880s, the fast growth of downtown San Diego included a new wharf, and La Playa ceased to be the busy anchorage it had been. As the residential community grew, much of La Playa remained a public beach. (SDHC.)

Two

NEIGHBORHOODS OF POINT LOMA

The community of Point Loma contains several distinct neighborhoods. The La Playa neighborhood begins at the origins of the La Playa Trail, where ships first landed at the southern end of the Point Loma peninsula. In 1866, Louis Rose laid out Roseville, which competed with the city of San Diego and eventually joined it. The area became home to many Portuguese families and became known as Tunaville during the peak years of the tuna fishing industry. The commercial district in Roseville is primarily on Rosecrans Street and is often called the Village. Loma Portal offers cherished character homes from the early 1900s set off by unique streetlights in the middle of its intersections rather than the standard placement on a corner. Loma Portal shares the alphabetical "author streets" with neighboring Roseville, with names from Addison to Zola and Alcott to Lytton.

After the Theosophical Society moved to Pasadena after the Great Depression, some of its property at Lomaland was subdivided into tracts of housing now known as the College Area. The Wooded Area, between La Playa and Lomaland, offers a rural feel with few sidewalks and many trees. Known for its spectacular display of Christmas lights, Fleetridge, the hilly area above Loma Portal, was developed in the 1950s.

During the 1915 Panama-California Exposition in San Diego, sporting goods tycoon Albert Spalding invested over $2 million in constructing bridges, trails, and stairways for access to the ocean from his Sunset Cliffs Park. Today, Sunset Cliffs offers beautiful ocean and sunset views and is a prized residential area.

Point Loma's newest residential neighborhood consists of 849 homes built as part of the redevelopment of the former Naval Training Center and now known as Liberty Station. Five hundred of these homes are reserved for military housing.

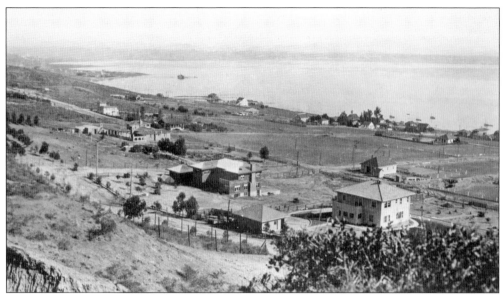

Bordered by San Diego Bay to the east, the naval base to the south, the Wooded Area to the west, and Roseville to the north, La Playa is one of the oldest neighborhoods in Point Loma. Looking northeast from the top of Kellogg Street, the view in this 1913 photograph shows Sandy Point, which would later be developed into the Southwestern Yacht Club. (SDHC.)

Located across the channel from the sandbar (which would later become Shelter Island) and flanked by historic estates to the west, Kellogg Beach was the spot where local children learned to swim. With its calm water and sandy shoreline, it is still a favorite spot for families today. (Courtesy of Suzanne Small Schrum.)

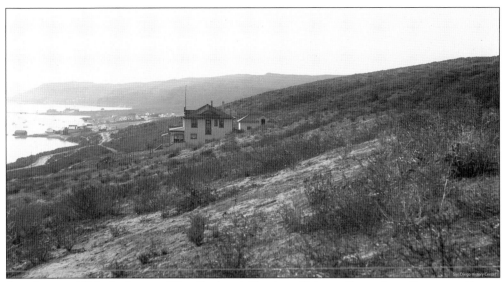

Seen here in 1898, the home of Drs. Fred and Charlotte Baker still stands on Rosecrans Street. One of the earliest homes built in La Playa, it also had the distinction of being the first with telephone service. Dr. Fred Baker was instrumental in helping to start many organizations in San Diego, including the San Diego Historical Society and Scripps Institute of Oceanography. His wife, Dr. Charlotte Baker, holds the honor of being the first female physician in San Diego and has been inducted into the San Diego Women's Hall of Fame. (SDHC.)

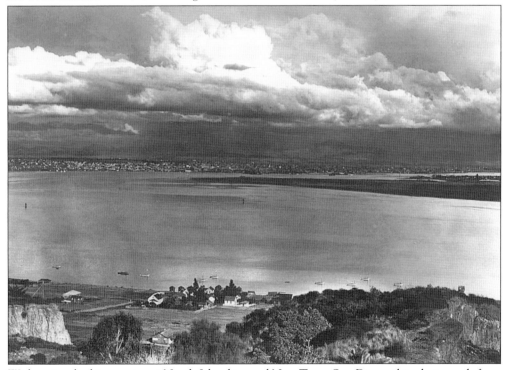

With a view looking east past North Island toward New Town San Diego, this photograph from the end of the 19th century shows the beginnings of an early La Playa neighborhood. (Courtesy of the Theosophical Society, Pasadena.)

Once a separate town called Roseville-on-the-Bay, Roseville is the oldest settled part of the peninsula. Jewish immigrant Louis Rose arrived in Point Loma in 1850 and purchased 325 acres of land for just under $82. A great visionary regarding the future of Point Loma, Rose subdivided the land and built a wharf, a hotel, a general store, and a Jewish cemetery in hopes of turning Roseville-on-the-Bay into the New Town of San Diego. (SDHC.)

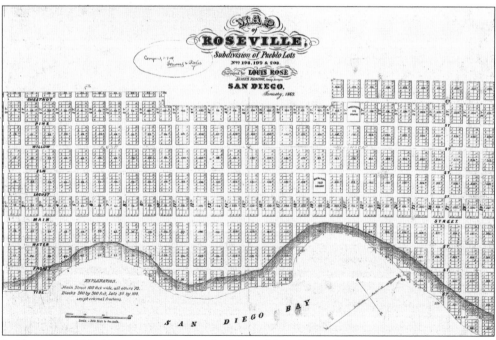

Laid out in grid fashion, Roseville stretched from Main Street (Rosecrans Street) to the east, Chestnut Street (Clove Street) to the west, First Avenue (Avenida de Portugal) to the south, and Thirtieth Avenue (Dumas Street) to the north. Louis Rose also donated two large parcels of land to be used as town squares. Offering breathtaking views of the ocean and the bay, they were to be named Buena Vista and Washington Squares, but they were never developed. (Courtesy of the County of San Diego, public domain.)

Frank and Inez Jennings arrived in Roseville in the late 1800s. With his partner, George Crippen, Jennings purchased the land south of Rose's wharf and east up the canyon all the way to the ocean. After raising his family in Roseville and becoming one of the first sheriffs of San Diego County, Jennings remained there with his family into the next century. Jennings and Inez Streets are named in their honor. (SDHC.)

Jennings and Crippen bought the old nail mill factory at the foot of Bessemer Street, seen here to the left of Rose's wharf. It would serve as the first assembly hall, the first church, and the first school in Roseville. The building was later leased to a screen wire company and was demolished by the beginning of the 20th century. (SDHC.)

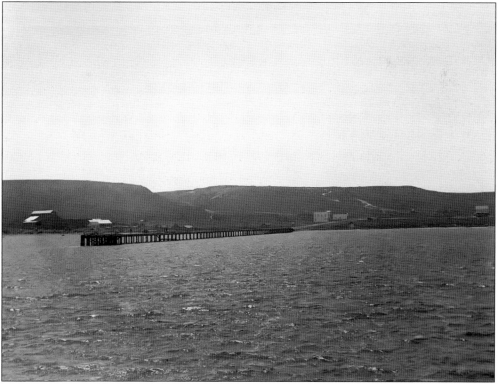

Frank Jennings built his first home in Chicken Ranch Canyon (current-day Talbot Street). Moved to its present location on Rosecrans Street, it remains one of the oldest structures in Roseville. (Photograph by Stuart Hartley.)

With the gradual deposit of sand and soil from the San Diego River, a large sandbar formed to the east of Roseville in San Diego Bay, as seen in this 1930s photograph. Using dredged material from the bay, this sandbar was built up and connected to mainland Point Loma in 1934. It was developed into Shelter Island in the 1950s, with hotels, restaurants, marinas, boatyards, and public parklands. It is hard to imagine that this thriving community was once just a sandbar visible only at low tide in the bay. (SDYC.)

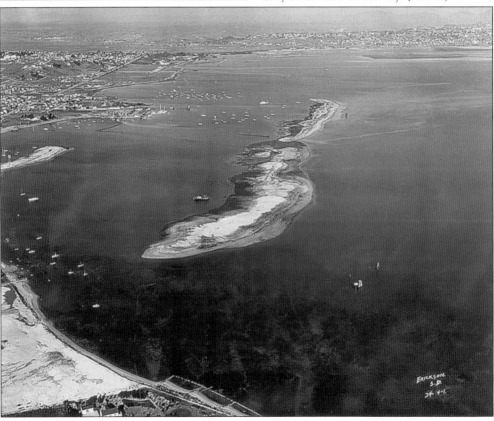

Loma Portal, northwest of Rosecrans Street and northeast of Nimitz Boulevard, is the only community in San Diego that has streetlights placed in the middle of its intersections. Its east-west streets are all named for famous authors. (Photograph by Stuart Hartley.)

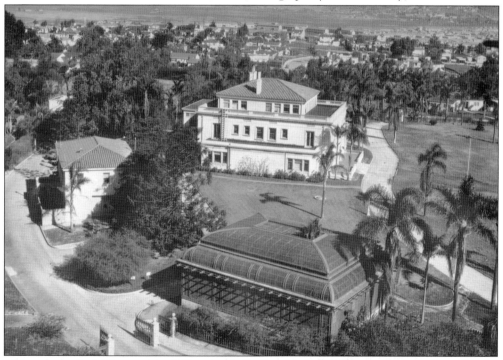

Rising above the highest point of Chatsworth Boulevard, the Bridges estate was built in 1911 for Amelia Timken Bridges, daughter of roller-bearing inventor Henry Timken. The carriage house once operated as the laboratory for Royal Rife, inventor of the monochromatic microscope lens. The original mansion has been cut in two, and part of the estate's original wrought iron fencing still surrounds many of the homes built on the subdivided land. (SDHC.)

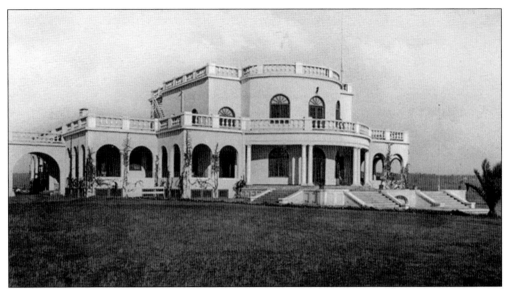

Built by Albert Spalding in 1914, the Point Loma Golf and Country Club once stood where Locust Street ended, just north of Lytton Street. It was demolished in the early 1920s when the Navy took part of the club's golf course for the Naval Training Center. The land where the country club once stood was subsequently subdivided for housing. (Courtesy of the Coons Collection.)

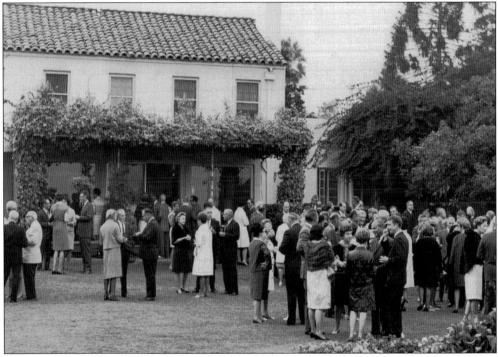

With their distinctive Spanish Colonial style and extensive terraced gardens, the four officers' quarters of the old Naval Training Center have stood proudly on Rosecrans Street for over 70 years. The homes housed the commanding officers and their families, who welcomed visiting dignitaries with lavish garden parties. The homes were vacated in 1997 with the closing of the training center. (Courtesy of Alan Ziter.)

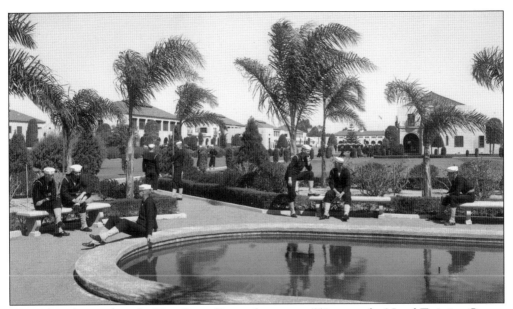

Located at the north end of San Diego Bay and covering 550 acres, the Naval Training Center was commissioned in 1923. Architect Frank Walter Stevenson designed the first buildings at the training center (many of which still stand today) in the Mission Revival style. The base reached its largest population of 40,000 during the Korean War. This photograph was taken at the Officer's Quarters A, which housed some of the highest-ranking Navy personnel and their families. The Naval Training Center closed in 1997, and the site is now occupied by Liberty Station. (SDHC.)

Built on the foundation of the Naval Training Center, Liberty Station has become a favorite Point Loma destination for residents and visitors alike. The preservation of its historic buildings, the military and nonmilitary housing, the marketplace district, the schools, and the many shops and restaurants all blend together to create a lively and unique community. (Photograph by Stuart Hartley.)

Until the mid-1950s, the hilly area above Roseville remained untouched, as seen in the 1952 photograph above with a view looking northwest from the end of Akron Street. Old-timers still reminisce about their days riding bikes over the open hills, running along the dirt paths, and enjoying their vast playground that would one day become the Fleetridge neighborhood. Between 1950 and 1955, David Fleet, son of Reuben H. Fleet, developed the area that is named for him. It is an entirely residential neighborhood graced by curving streets and large custom homes. Taken from roughly the same spot as the above photograph, the image below shows the vast development that has taken place over the last 60 years (Above, courtesy of Jim Baker; below, photograph by Stuart Hartley.)

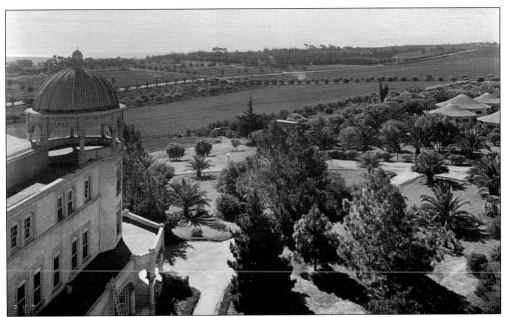

Originally called the Woodlands, the Wooded Area of Point Loma encompasses the hilltop area south of Talbot Street and both sides of Catalina Boulevard. Totally barren in its earlier days, this neighborhood is now filled with hundreds of trees and shrubs planted by Katherine Tingley's Theosophical community in the early 1900s. (Courtesy of the Theosophical Society, Pasadena.)

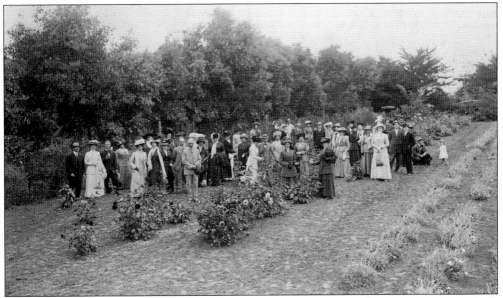

In 1903, Alfred D. Robinson bought several acres of barley fields from Katherine Tingley, which would eventually become Rosecroft Gardens and Rosecroft Estate. Robinson developed more than a hundred new varieties of begonias in his garden, and also originated the idea of using lath houses to grow tropical plants in temperate climates, thus inspiring the Botanical Building in Balboa Park. Opened to the public in the 1940s, the gardens were eventually subdivided in the 1970s for single-family homes. (SDHC.)

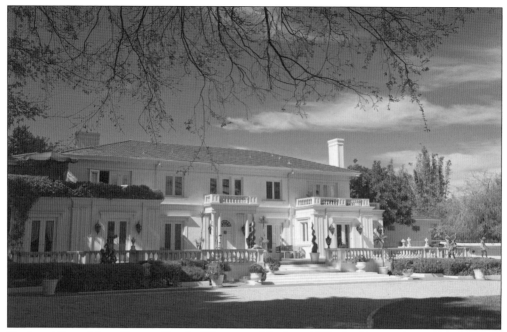

Designed by architect Emmor Brooke Weaver and built in 1912, the Rosecroft mansion boasts a ballroom, a garden room, a library, and six fireplaces among its living spaces. Although the home originally sat on over 10 acres of land, all that remains of its beautiful gardens is part of the old stone wall that once surrounded it. (Photograph by Stuart Hartley.)

Built in the 1920s and sometimes called the Spanish Castle, the majestic estate of Reuben H. Fleet overlooks San Diego Bay. Fleet arrived in San Diego in 1935 and founded Consolidated Aircraft, which sold seaplanes and Liberator bombers to the US government and its allies. A lover of golf, Fleet used the area to the west of his home (current-day Via Flores) to build his own private golf course. (Photograph by Stuart Hartley.)

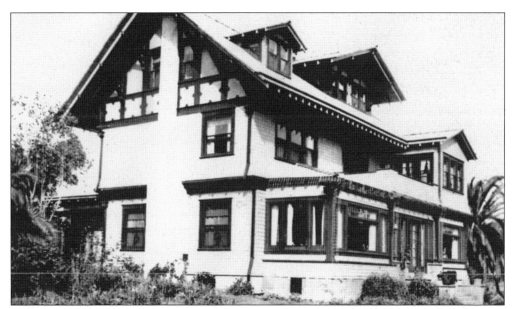

The home of Lyman Gage, secretary of the Treasury under President McKinley, once stood near the end of what is now Gage Drive. Gage, who was also instrumental in creating the Panama-California Exhibition of 1915, purchased the land when he became a member of Katherine Tingley's Theosophical Society in the early 1900s. (Memoirs of Lyman Gage, public domain.)

The Neresheimer-Tingley House, more commonly known as Sunnyside, was built in the early 1900s and is on the list of registered landmarks in Point Loma. Appointed as president of the Theosophical Society, August Neresheimer was a diamond broker from New York who bankrolled much of Katherine Tingley's Theosophical Society enterprise. The Victorian house was originally built for Tingley but was later used as a guest home for women visiting Lomaland. (Photograph by Stuart Hartley.)

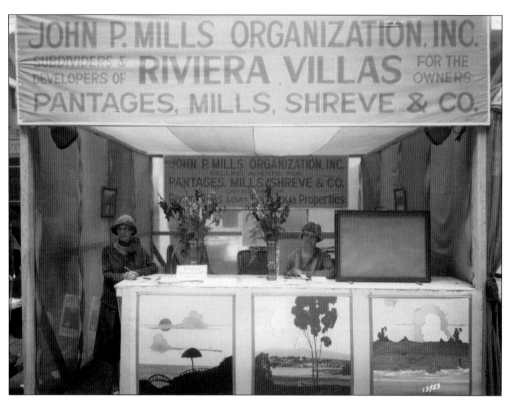

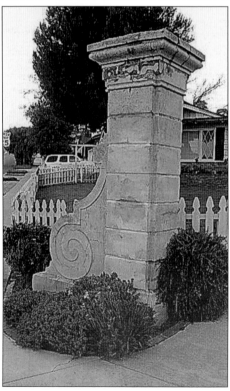

In 1924, along with partners Alexander Pantages and Jesse Shreve, John P. Mills purchased 300 acres of land along Sunset Cliffs that had originally been owned by Albert G. Spalding. Pantages, Shreve, and Mills paved the streets and touched up Spalding's park with its ornate bridges and cobblestone paths. They built Spanish Eclectic houses at key intersections and strategic viewpoints to serve as model homes for their new community. Within two years, the lots went up for sale, as seen in this 1928 photograph. (SDHC.)

By 1927, Pantages, Mills, and Shreve had opened three new tracts: Cornish Heights and Riviera Villas at the top of the hill and Azure Vista to the south. They erected two matching pillars to serve as an entryway to the Riviera Villas development at the corner of Santa Barbara Street and Catalina Boulevard. Situated on opposite sides of the street, these pillars stood for years before one was knocked down by a car, and the other was completely hidden beneath overgrown branches and shrubbery. Uncovered in the 1980s, this remaining pillar still stands proudly as a reminder of Point Loma's past. (Photograph by Eric DuVall.)

In 1926, John P. Mills began building this 12-room mansion across from Spalding's Sunset Cliffs Park. Along with its four large Corinthian columns, hand-painted gilded ceilings, and paneled rosewood walls, the home had a 19-horse stable in the rear where Mills kept his favorite racehorse, Osprey. This home was one of many along the coast that was used for smuggling alcohol during Prohibition. (Photograph by Stuart Hartley.)

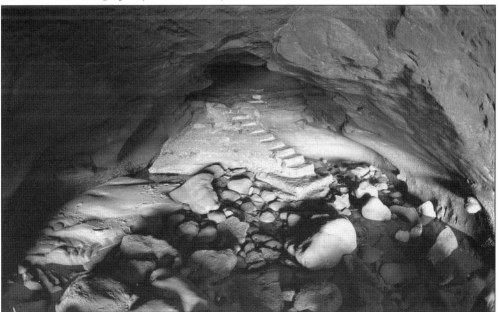

Entering the cave below the Mills mansion, smugglers would deliver their goods through a tunnel that has long since been boarded up. The tunnel led to a set of steps that could be accessed through a trapdoor in the floor of the mansion. Today, remnants of this bootlegger's cave can be seen from time to time, depending on the tide. (Photograph by Tom Shjarback.)

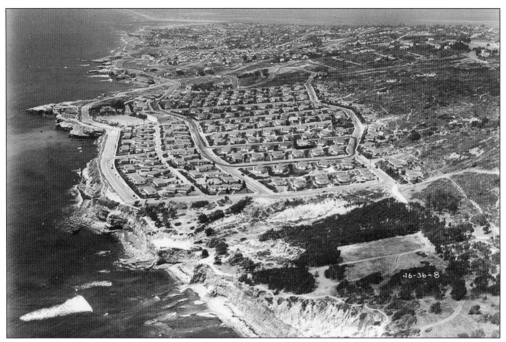

Bordered by Hill Street to the north, Cornish Drive to the east, Ladera Street to the south, and Sunset Cliffs Boulevard to the west, Azure Vista was the site of a 400-unit government housing project from 1941 until 1957. Along with bunkers overlooking the Pacific and two pay phones per street, Azure Vista also had its own community center, school, post office, and general store. (Courtesy of the Pacific Beach Historical Society.)

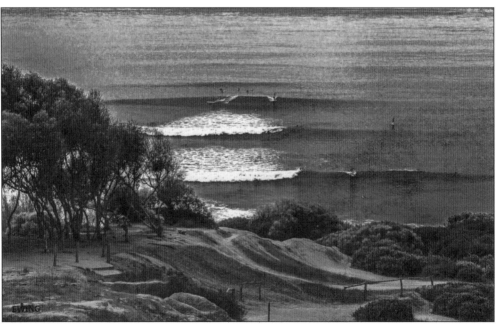

Standing on Sunset Cliffs overlooking the Pacific Ocean, one can still breathe in the scent of Point Loma's glorious past. (Photograph by Joe Ewing.)

Three

THE MILITARY ARRIVES

San Diego's first harbor defense was an adobe fortification known as La Punta de los Guijarros, which was constructed in the lee of Point Loma peninsula by the Spaniards in about 1797. None of this stronghold remains visible today, except for artifacts unearthed between 1982 and 2011 by members of the former Fort Guijarros Museum Foundation. In 1821, San Diego became a part of the newly independent Mexico, then part of the United States following the end of the Mexican-American War in 1848 and the admission of California to the union in 1850.

In 1852, US president Millard Fillmore signed an executive order to create a military reservation at the tip of the Point Loma peninsula. The reservation included the outer end of the peninsula to a line running east and west through the center of La Playa, a landmass covering two miles at its widest and nearly three miles long. Gun emplacements began to dot the tip of Point Loma as early as 1870, and by 1904, the US Army post of Fort Rosecrans was completed. In 1959, the post was transferred to the US Navy, eventually serving as a homeport for the Pacific Fleet's nuclear attack submarines.

Point Loma residents experienced an economic boost with the 1921 commissioning of the Marine Advanced Expeditionary Base, San Diego, which would ultimately become Marine Corps Recruit Depot, San Diego (MCRD). Also, the 1923 commissioning of the Naval Training Station along Rosecrans Street—later known as Naval Training Center (NTC)—added 70 years of neighborhood enthusiasm. But alas, in 1993, the federal Base Realignment and Closure Commission slated NTC for closure. Today, Point Loma's military pride remains evident as submariners return to port and are greeted with civilian "Welcome Home" banners along Rosecrans Street. Base closures and reassignments have altered the military's presence on the peninsula, but its status and history are nonetheless revered.

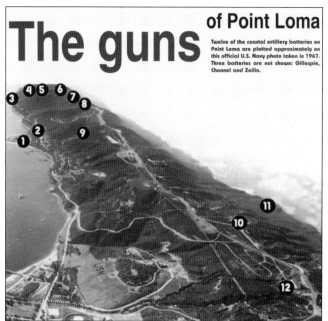

The guns of Point Loma

Twelve of the coastal artillery batteries on Point Loma are plotted approximately on this official U.S. Navy photo taken in 1967. Three batteries are not shown: Gillespie, Channel and Zeilin.

Most of the named artillery batteries on Point Loma recognize servicemen killed in battle, including: 1. Wilkeson-Calef (four 10-inch disappearing rifles) and Fetterman (two 3-inch guns); 2. McGrath (two 5-inch guns, later two 3-inch guns); 3. Bluff; 4. Humphreys; 5. Cliff (two 37-millimeter antiaircraft guns); 6. Cabrillo; 7. Point Loma; 8. Ashburn (one 16-inch gun); 9. White; 10. Strong; 11. Woodward; and 12. Whistler. (Courtesy of Traditions Military Videos.)

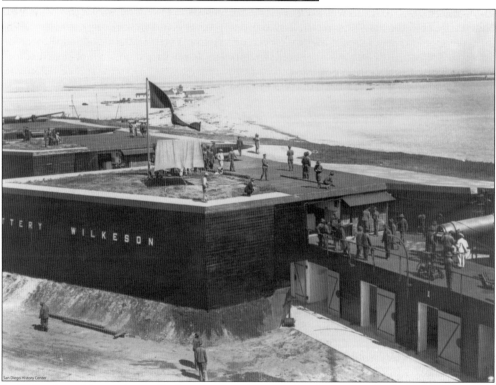

In 1896, after a 20-year dry spell of government focus on fortifications at Ballast Point, Congress finally ordered construction of a reinforced concrete Coast Artillery battery to house four 10-inch rifles mounted on disappearing carriages. While it was initially named Battery Wilkeson in 1915, the name Calef was added to two of its guns. The battery's concrete skeleton still stands today. (SDHC.)

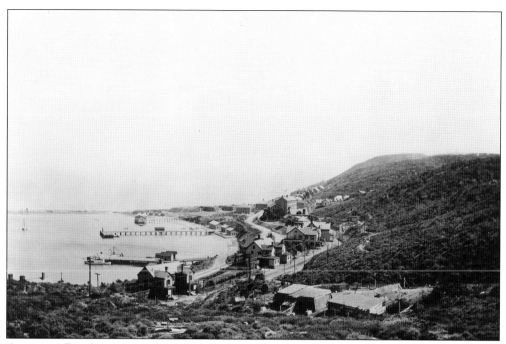

Army post Fort Rosecrans was named for Civil War general William Starke Rosecrans in 1898. Interestingly, Abraham Lincoln invited Rosecrans to join his presidential ticket, but Rosecrans delayed his response. By 1911, wharves, officers' quarters, barracks and noncommissioned officer housing, a hospital, and subsistence structures were well established. Note the fort's proximity to the bay. (Courtesy of the Ruhlen Collection.)

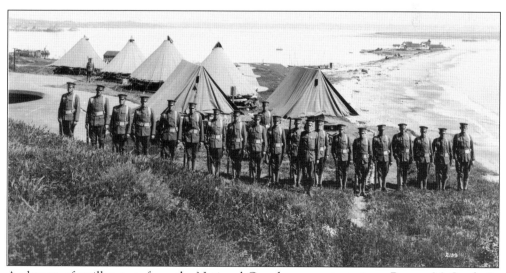

A platoon of artillerymen from the National Guard prepares to train at Battery McGrath. In 1911, the slender dirt pathway to Ballast Point Light Station was at times nearly underwater and was always at the whim of the tides. (Courtesy of Paul Holtz Camera.)

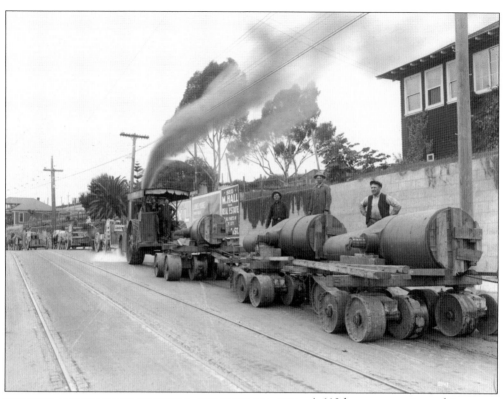

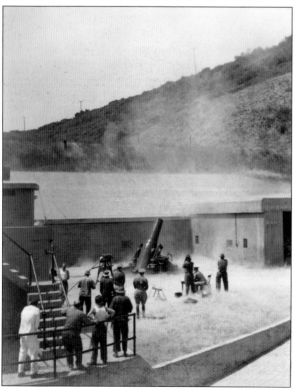

A 110-horsepower steam-driven Case ordnance tractor trundles along Rosecrans Street, its trailers burdened with 12-inch mortars. Four of these 1890-model guns would be installed at each of two batteries at Fort Rosecrans, White and Whistler, between 1915 and 1919. Horse-drawn carts lead the convoy transporting components for military operations. The arrival of mortars and their carriages was delayed because the Army was considering installing newer M1912-model guns versus recycling guns removed from Fort DuPont, Delaware. Above, those recycled mortars are being delivered to Fort Rosecrans. At left, artillerymen practice firing one of four mounted at Battery White in 1936. (Above, courtesy of Cabrillo National Monument; left, SDHC.)

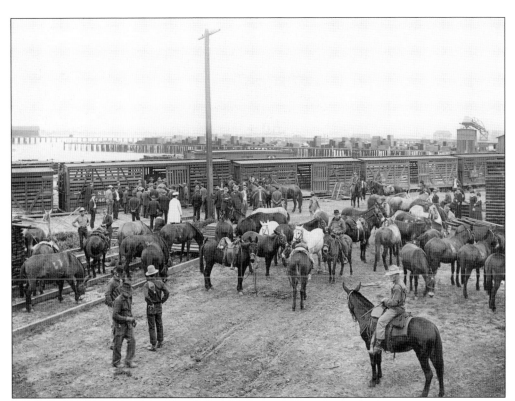

Southern Pacific livestock cars are unloaded at the waterfront near Union Station (known as the Santa Fe Depot), where soldiers from Fort Rosecrans collect their equine transports. Long wharves reach into San Diego Bay laden with what appear to be stacks of lumber, or a mistaken 1914 skyline. (SDHC.)

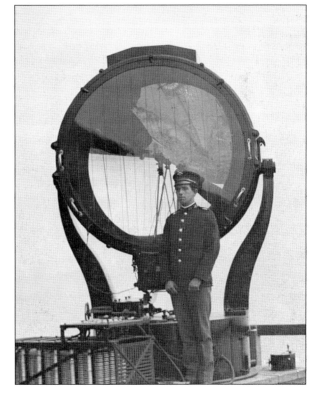

Fifteen 60-inch GE carbon-arc searchlights were hidden in the hills of Point Loma. Some were housed in small, camouflaged buildings and rolled to position along narrow-gauge tracks; others rose from beneath the ground in pop-up shelters. Each searchlight put out 800 million candlepower. Soldier Paul T. Mizony wears the handsome 1904 dress blue Army uniform. (SDHC.)

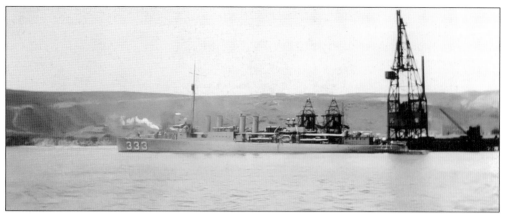

USS *Sumner* (DD-333) replenishes her fuel supplies in 1923 at the Navy coaling station. The city's first naval shore installation was established in 1904 as La Playa Coaling Station. As fuel sources evolved, the addition of a bulk fuel tank in 1917 may have been warmly received by coaling personnel. Coal bins and their accompanying black dust were removed by 1927. (Courtesy of the Phelan Collection.)

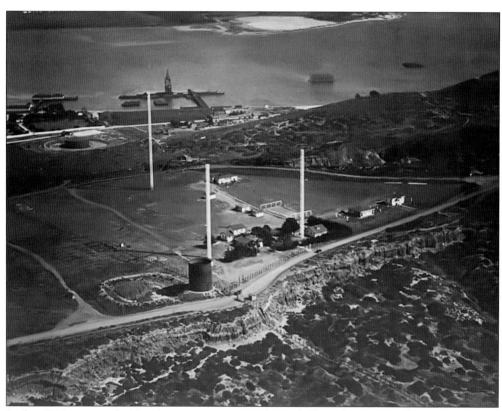

In this 1924 view are the Navy's quarantine station (upper left), coaling station (upper center), and wireless radio station (at center). Out of a small wooden building housing a 5-kilowatt transmitter, San Diego became part of the Navy's first radio communications network. Navy Radio Point Loma was commissioned in 1917. (Courtesy of the National Archives and Records Administration.)

Marine colonel Joseph Pendleton, with the assistance of Congressman William Kettner, secured 388 acres of bay tidelands called Dutch Flats (most of it reclaimed tidal area) in 1916 for the new Marine Advanced Expeditionary Base, San Diego. Commissioned in December 1921 to train and "make Marines," the installation was renamed Marine Corps Recruit Depot, San Diego in 1948. (Courtesy of the Phelan Collection.)

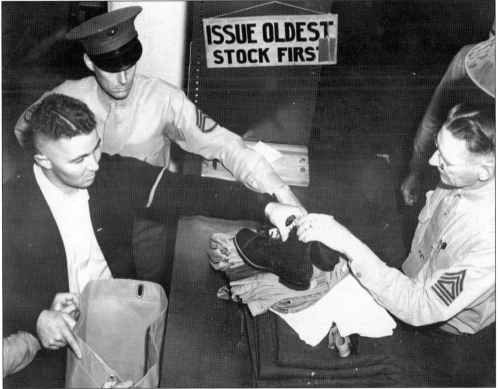

George Temple, brother of famous juvenile movie star Shirley Temple, was one of 3,000 new Marine Corps recruits learning how to march, handle a rifle, and adjust to the rigorous routine of the military outfit. On October 23, 1940, Temple poses with platoon sergeant C.H. Withey and quartermaster sergeant Speer. (Courtesy of the Phelan Collection.)

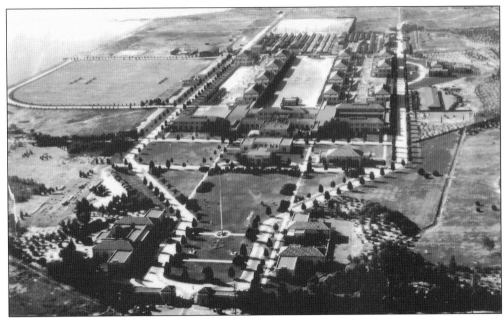

Point Loma has seen many sailors come and go while businesses along Rosecrans Street thrived. Commissioned in 1923, Naval Training Station San Diego (later Naval Training Center San Diego) sprawled across 135 acres of highland donated by the San Diego Chamber of Commerce and 142 acres of tideland given by the City of San Diego. Between 1923 and 1997, two million men and, eventually, women trained for Navy service here. (Courtesy of the NTC Foundation.)

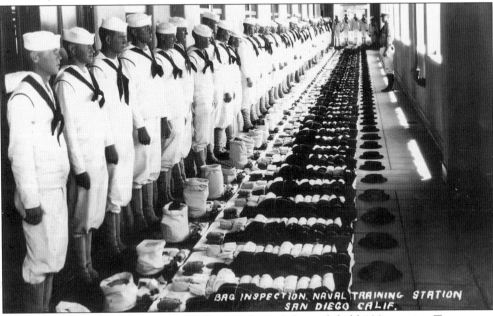

NTC's architecture was inspired by Balboa Park. Each barrack held 100 recruits. To promote teamwork, the recruits divided into companies that were pitted against each other in seabag, personal inspection, and barracks cleanliness competitions. Today, 52 historic NTC buildings are restored as part of the new Liberty Station neighborhood of Point Loma. (Courtesy of the Phelan Collection.)

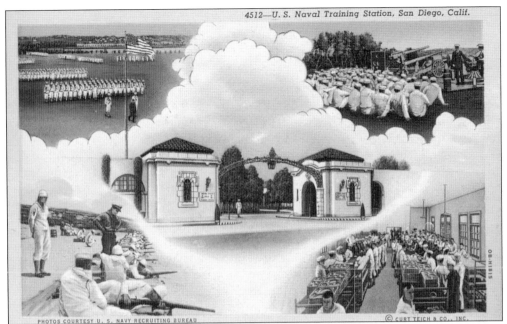

Gate One on Lytton Street was the first gate at NTC and for many years was the only gate open at night for sailors returning from leave. The decorative arch was added in 1932. Goals of training included instilling and reinforcing the Navy's core values of honor, courage, and commitment along with the basic skills of seamanship in a team environment. (Courtesy of the NTC Foundation.)

At Luce Auditorium at the Naval Training Station, many recruits enjoyed big band leaders like Tommy Dorsey, Kay Kyser's Kollege of Musical Knowledge, and Hollywood entertainers. Here, Bob Hope signs autographs at the Naval Training Station in 1941, where he presented two shows as part of his schedule of programs at West Coast Army posts and Navy bases. (Courtesy of the Phelan Collection.)

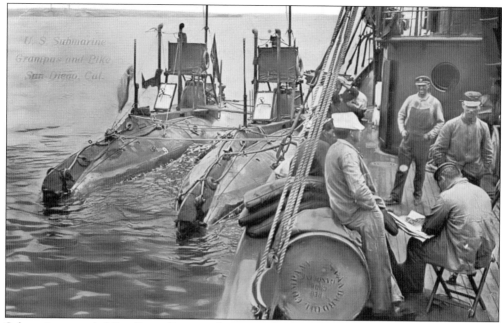

Submarines prowled San Diego Bay as early as 1910, but it would be another 50 years before more modern boats would call Point Loma home. US submarines *Grampus* and *Pike*, shown tied to a support vessel, docked for a year at Point Loma's coaling station. These 64-foot submarines, really surface ships made to submerge, were limited to four to six hours underwater. (Courtesy of the Maritime Museum of San Diego.)

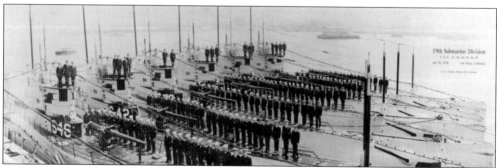

In 1928, a nest of the newer S-class submarines are moored to each other on San Diego Bay, with personnel of the 19th Submarine Division in town for training. No longer built for harbor defense, the S-class of 51 boats was the Navy's first true oceangoing attack submarine, but it had no place to dock yet at Point Loma. (Courtesy of the Naval History and Heritage Command.)

Following the bombing at Pearl Harbor in 1941, a blackout was declared over Point Loma, and military installations were hidden. To improve shipboard communications, the military consolidated the US Navy Radio and Sound Laboratory with the University of California Division of War Research to form NEL in 1946. (Courtesy of the US Navy.)

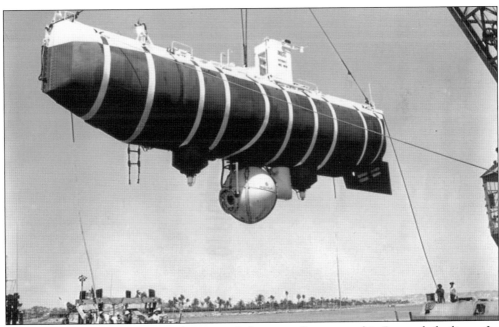

Suspended above the US Navy Electronics Laboratory Oceanographic Research facility at La Playa is the manned submersible, or bathyscaphe, *Trieste*. The Navy purchased the vessel and brought her to San Diego for alterations and test dives. In 1960, Navy submariner Don Walsh and Swiss engineer Jacques Piccard boldly navigated *Trieste* to the deepest part of Earth's oceans at Mariana Trench near Guam in the Pacific. (Official US Navy Photograph.)

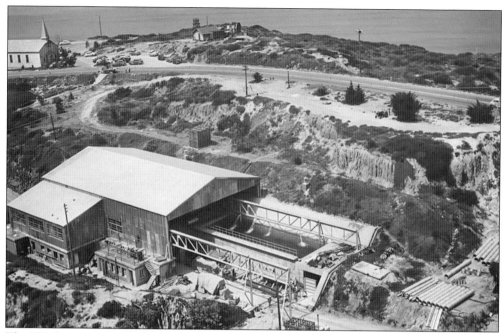

The US Army constructed a network of coastal defense batteries in various locations around Point Loma, including Battery Whistler. With mortars removed, the battery was taken over by NEL in the 1940s and reconfigured to become the Submarine Research Facility. In 1969, it was renamed Arctic Submarine Laboratory. (Official US Navy Photograph.)

As one of its first projects, NEL built the Shipboard Antenna Model Range. The nonmetallic arch of this structure is a Point Loma landmark that supports a transmitting antenna positioned toward a brass model ship on a turntable. The ground plane under the arch simulates the electrical characteristics of the ocean, allowing research on the properties of shipboard antennas. (Official US Navy Photograph.)

44

Administration of lighthouses was transferred to the US Coast Guard in 1939, and keepers received military commissions. In the mid-1950s, the lantern and dwellings of Ballast Point Lighthouse were removed, a duplex built, and the beacon placed on the fog bell tower. The light station was fully razed by 1960, and the property was turned over to the US Navy. (Courtesy of Cabrillo National Monument.)

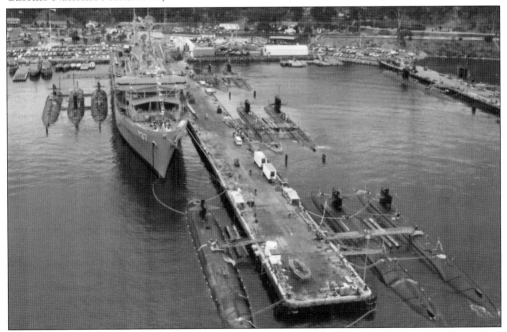

Larger and more capable submarines entered the bay regularly, and by 1949, Submarine Group San Diego was established at Point Loma. It became clear that advanced training of submariners was required and the Navy submarine support facility was installed in 1963. Moored in 1987 are the USS Dixon (AS-37) and various subs. (Courtesy of Thomas H. Adams, US Navy Photograph.)

The last Army unit stationed at the former Fort Rosecrans was the 710th Ordnance Company (Explosive Ordnance Disposal). These soldiers were called into Afghanistan following 9/11 to fight global terrorism. By 2007, the company transferred to Fort Lewis, Washington, though the transition of Army to Navy at Fort Rosecrans had long been under way. Today, the area is known as Naval Base Point Loma. (Photograph by Kim Fahlen.)

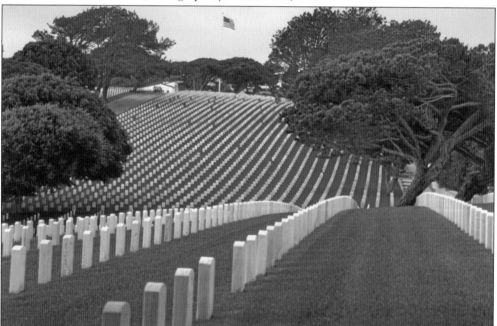

With military valor comes sacrifice, as evidenced by thousands of headstones at Fort Rosecrans National Cemetery. Veterans from the Battle of San Pasqual in 1846 and all wars since are honored here. In the 1870s, a one-acre burial ground served San Diego Barracks. When Fort Rosecrans was completed, the grounds became the post cemetery. The nearly 80 acres was awarded national status in 1934. (Photograph by Kim Fahlen.)

Four

LOMALAND

In 1901, a unique experimental community began to take shape at a remote location on the crest of the Point Loma peninsula. Three years earlier, 500 acres immediately north of the military reservation had been purchased by the Universal Brotherhood and Theosophical Society at the behest of its new leader, Katherine Tingley. A humanitarian visionary, Tingley intended to create an international community of freethinkers dedicated to the study of the arts, sciences, philosophical and religious traditions from around the globe, and the wisdom of the ages. The school she imagined and planned, the School for the Revival of the Lost Mysteries of Antiquity, never materialized. The school she did start, the Raja Yoga Academy, later the Raja Yoga College, became one of the more highly regarded educational institutions in the country.

The Theosophists on Point Loma constructed lovely, eclectic, and fanciful buildings characterized by large glass domes that were illuminated at night and could be seen for miles. They also cultivated a large portion of the estate and thousands of trees. One of Point Loma's neighborhoods became known as the Wooded Area as a direct result of the Theosophical Society's forestry program. The community became known as Lomaland, but it is important to note that before Lomaland there was no actual community called Point Loma. People lived in Ocean Beach and in Roseville, but in the early years of the 20th century, if an event was happening in Point Loma, or if someone said he or she was going to Point Loma, the site was actually the Theosophical Institute, Lomaland. While the Theosophical Society was conducting international relief efforts and peace conferences, the Lomaland community was becoming the cultural hub of San Diego. The Raja Yoga Orchestra toured internationally, and thousands turned out to see dramatic productions staged in Lomaland's unique Greek Theater.

The death of Katherine Tingley, a depressed economy, and World War II combined to undermine the long-term viability of the Lomaland community. By 1942, the Theosophical Society had moved on. Lomaland as it was is gone, but for 40 years, it was the best of—and in many ways the beginnings of—the community today known as Point Loma. Except where noted, photographs in this chapter are used courtesy of the Theosophical Society, Pasadena.

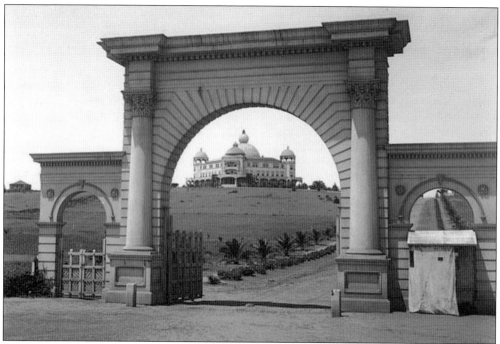

The Roman Gate frames the Raja Yoga Academy building in 1901. The road in the foreground, then called Point Loma Boulevard, is now known as Catalina Boulevard. Most of these young Canary Island date palms remain, lining the road going up the hill, now known as Lomaland Drive.

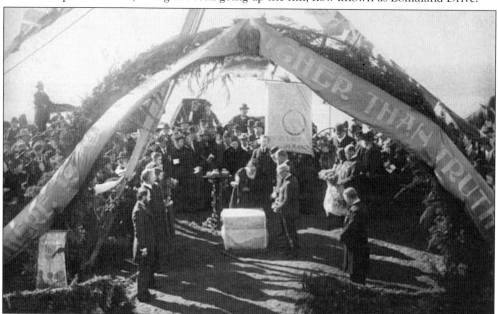

Katherine Tingley (center) lays the cornerstone for the projected School for the Revival of the Lost Mysteries of Antiquity at a ceremony on the top of Point Loma on February 23, 1897. San Diego was a town of only 17,000 at the time, yet over 1,000 people, including Mayor D.C. Reed and the City Guard Band, turned out for the occasion. The banner reads: "There is No Religion Higher than Truth."

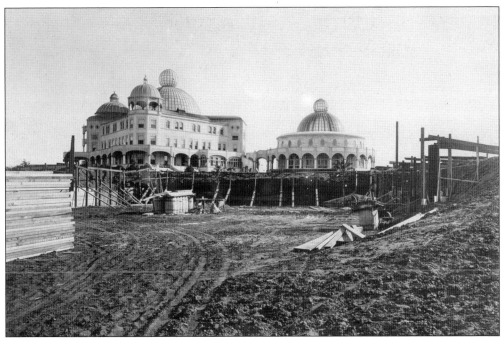

This 1901 view of the Raja Yoga Academy building, also known as the Homestead (left), and the Aryan Temple, more commonly referred to as the Temple of Peace, was taken from the excavation site for what would soon be the home of Albert and Elizabeth Spalding.

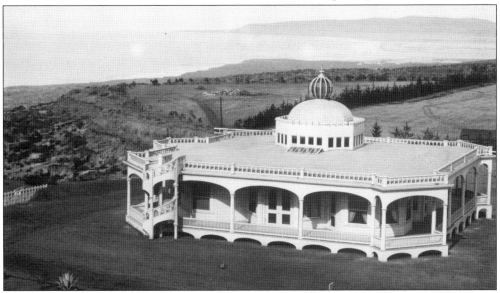

The athletic fields of Lomaland can be seen just past the home of sporting goods tycoon Albert G. Spalding and his wife, Elizabeth. Elizabeth Spalding was a prominent Theosophist and a confidante of Katherine Tingley. The couple lived in this home, now known as Mieras Hall and used for administrative offices by Point Loma Nazarene University, from 1901 until Spalding's death in 1915. At one point, Spalding owned over a thousand acres of real estate in San Diego. He became a particularly effective highway commissioner and ran unsuccessfully for the US Senate in 1909.

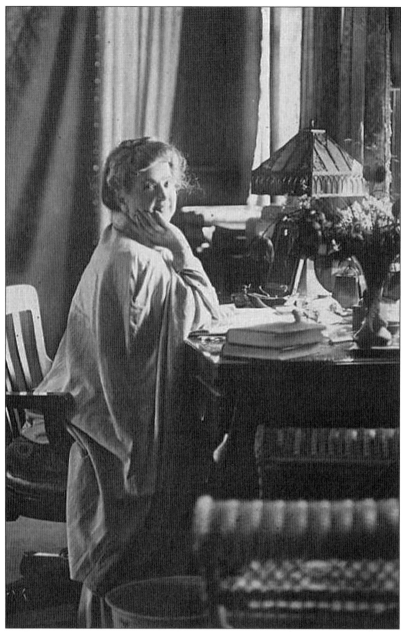

Katherine Tingley, here sitting in her office at Lomaland in 1915, became the leader of the American branch of the Theosophical Society following the death of William Quan Judge in 1896. A lifetime of philanthropy and hands-on relief work began for Tingley in 1862, when she was a teenager tending to Civil War casualties near her father's home in Virginia. As a young woman, she continued her relief work with the immigrant poor in New York City. As one of her first campaigns with the Theosophical Society, Tingley formed the International Brotherhood League in 1897. Later, the combined organizations became known as the Universal Brotherhood and Theosophical Society. Throughout her career with the Theosophical Society, and until her death in 1929, she was known as "Madame Tingley." Tingley moved the society's headquarters from New York City to Point Loma on February 13, 1900.

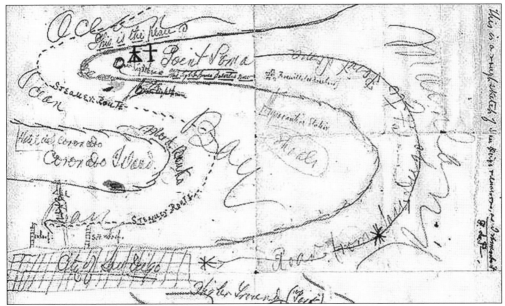

As a child in New England, Katherine Tingley had a dream of a white city on a hill in a golden land above the blue Pacific Ocean. This was to be a place where people from all countries could be brought together and where young people would learn to become true and strong and noble. In 1873, Tingley chanced to tell her dream, which she called a fairy story, to Gen. John C. Frémont. Frémont told her that he knew the place she had described, a peninsula called Point Loma that protected a large natural harbor in San Diego, California. Some 20 years later, Gottfried de Purucker, who had lived in San Diego and who would lead the Theosophical Society after Tingley's death, told her that he was familiar with Point Loma. This is his hand-drawn map.

Katherine Tingley steered the Theosophical Society toward international humanitarianism. She traveled widely, coordinating the society's relief efforts for refugees and campaigning against the First World War. Here, the Theosophical Permanent Peace Committee, with Tingley in the center, meets in the Temple of Peace in 1923.

It was a seven-mile trip by horse and buggy from New Town San Diego to the Lomaland estate on Point Loma. Here, in 1903, some traffic congestion is evident on the government road to the lighthouse, later to be named Point Loma Boulevard.

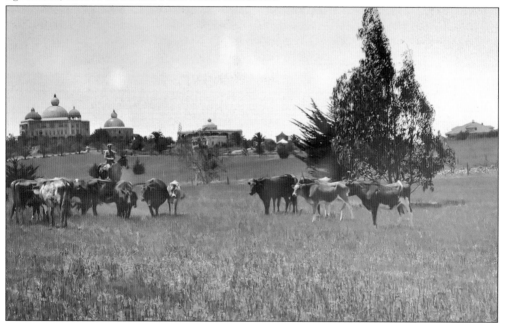

Lomaland was a self-contained community. Here, dairy cattle graze on the property in 1905. On the hill in the distance are the Raja Yoga School (left), the Temple of Peace (center), and the Spalding House. The Spalding House and the building on the far right, commonly referred to as the North House or the President's House, still stand. The North House backs up to what is now Moana Drive and serves as the Alumni House for Point Loma Nazarene University.

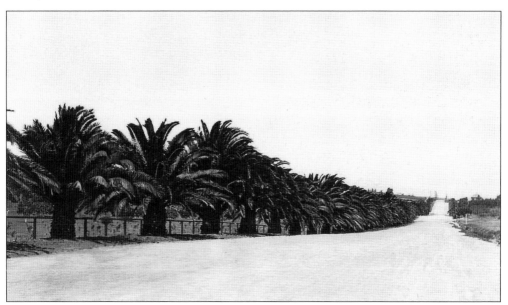

By 1909, Point Loma Boulevard, now called Catalina Boulevard, had been widened and graded. These improvements were in large part due to the hard work and influence of Albert Spalding, highway commissioner and Lomaland resident. (Courtesy of the Phelan Collection.)

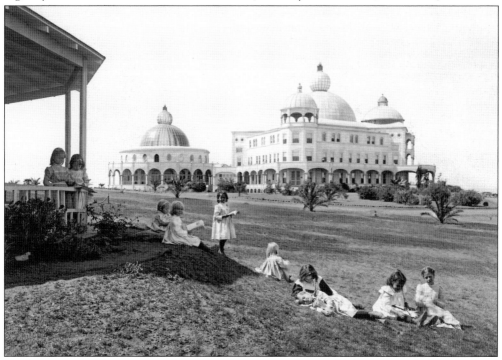

The beginnings of the extensive plantings and forestation that would characterize the Theosophical Society's tenure on Point Loma are evident in this photograph of Raja Yoga Academy schoolgirls reading on the lawn in 1901. The glass domes of the Temple of Peace (left) and the Raja Yoga School building were illuminated at night and could be seen from San Diego and Coronado and even from ships at sea. (SDHC.)

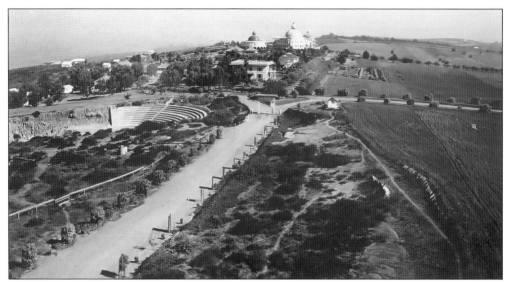

The Greek Theater and some of the acreage farmed by the institute are visible in this 1907 view of the Lomaland estate looking north. The Greek or Grecian Gate is seen to the immediate right of the theater, and beyond that gate lies what is still known as Pepper Tree Lane. The two-story building just past the Greek Theater was the headquarters and home of Katherine Tingley. The road leading off to the right of the photograph, now called DuPont Street, was at this time known simply as the road to the Greek Theater.

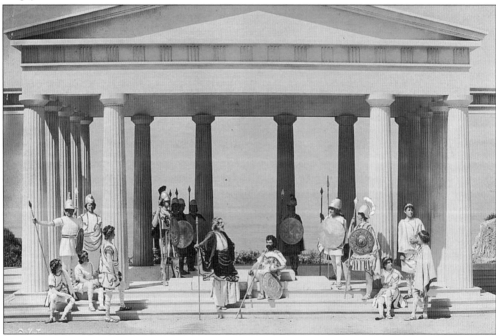

Built in 1901, the Greek Theater was the first of its kind in North America. It soon became the cultural hub of small-town San Diego, staging plays, concerts, pageants, ceremonies, and many other events. Here, an original Lomaland production, *The Aroma of Athens*, directed by Madame Tingley, is presented in 1911. The evening performances of this production featured what is believed to be the first use of outdoor electric theatrical lighting in America.

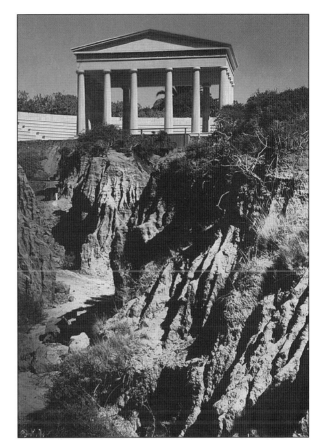

The Doric Stoa of the Greek Theater (right), here seen in a view looking east from the canyon, was erected in 1910. It was built as a replica of a similar theater in Taormina, Sicily. In addition to classical Greek dramas, Lomaland also staged several Shakespearean plays (below). Raja Yoga Academy schoolchildren portray fairies vexing the hapless Bottom in a 1915 Greek Theater production of *A Midsummer Night's Dream.*

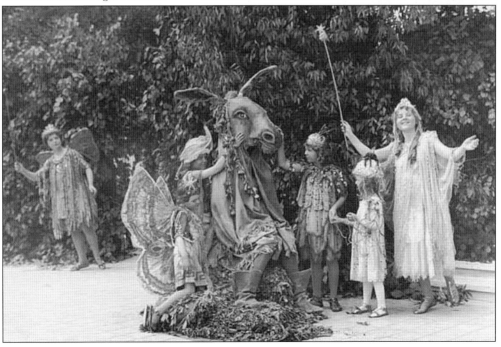

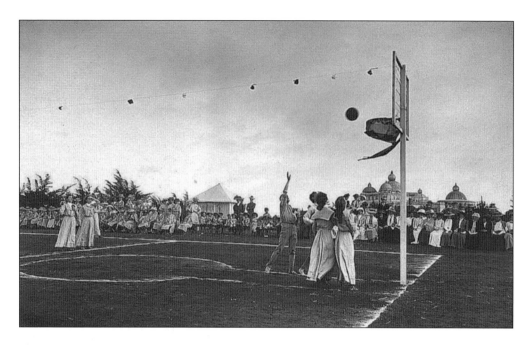

Activities on the Lomaland estate were quite varied, to say the least. Above, a rather formal game of coed basketball is well attended in 1904. Below, Fredrick J. Dick instructs his meteorology students at the Lomaland weather station, which may still be found on the campus of Point Loma Nazarene University. A civil engineer from Ireland, Dick also taught astronomy, math, and physics at the Raja Yoga Academy.

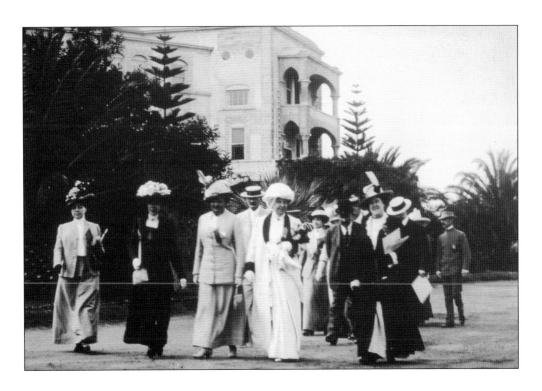

Above, Madame Tingley (center, in white) walks with members of the Southern California Editorial Association. The association, of which Tingley was a vice president, visited Lomaland on June 21, 1912. The cliffs below are not much changed after 100 years, and locals may recognize this trail. Raja Yoga schoolchildren enjoy a picnic on the beach below the Lomaland estate in 1909.

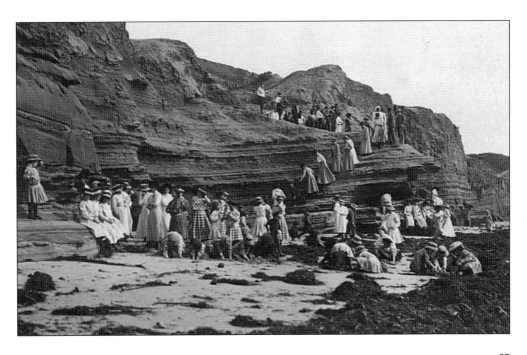

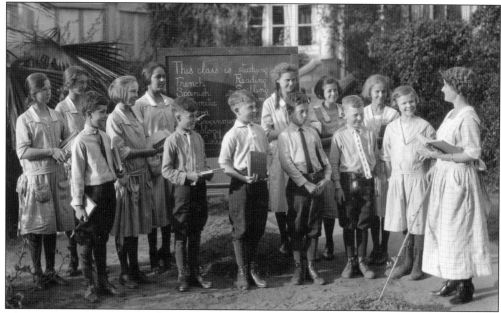

The Raja Yoga School began with five students in 1900. The school expanded over the years from an academy for middle and high schoolers to a university by 1919. The Raja Yoga system aimed to educate the whole person. In addition to very strong academics, art, music, physical, moral, and spiritual education were balanced parts of the program. In this photograph, a class poses outside the school in 1923.

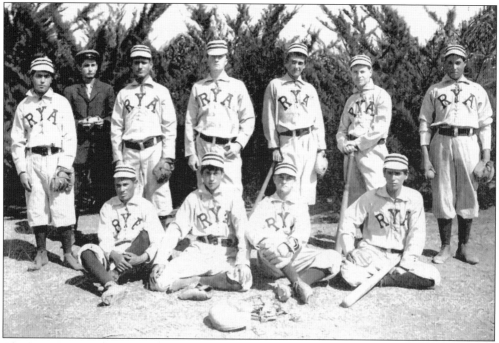

The Raja Yoga Academy baseball team poses on the athletic field in 1909. Iverson L. Harris (seated second from right) would go on to work as Madame Tingley's traveling secretary for many years. (SDHC.)

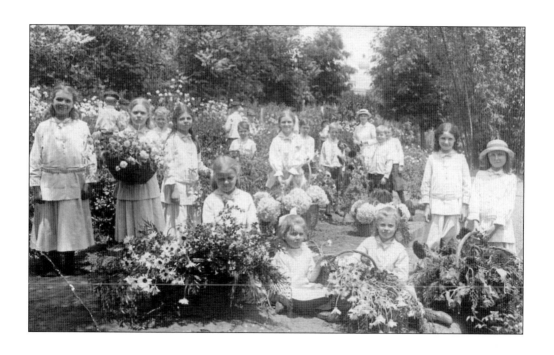

Above, Raja Yoga schoolchildren pick flowers in 1915. Over 100 acres on the crest of Point Loma were cultivated by the Lomaland community. Below, schoolgirls jump rope on the athletic field above the Pacific Ocean in 1905. (Above, courtesy of the Phelan Collection.)

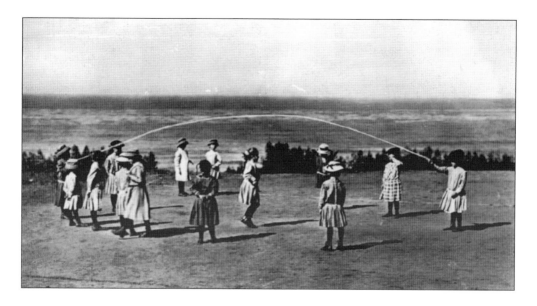

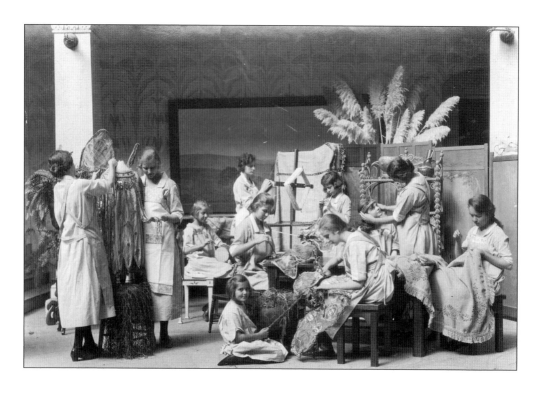

Practical subjects were an integral part of the Raja Yoga curriculum. Young women and girls are seen sewing in the above photograph. Below, schoolboys work out on the bars in 1910. (Courtesy of Ken Small, Point Loma School of Theosophy.)

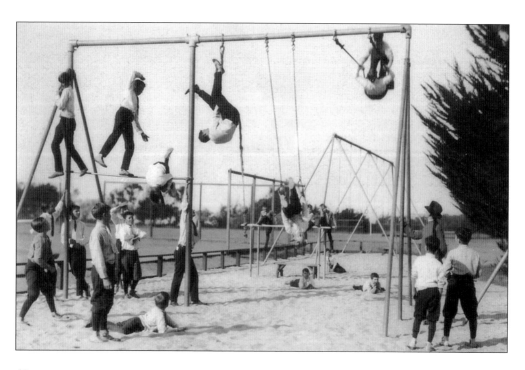

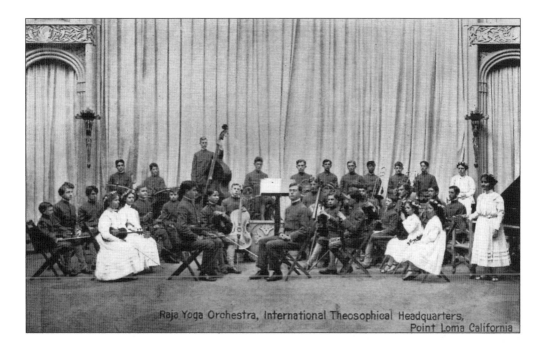

Raja Yoga Orchestra, International Theosophical Headquarters, Point Loma California

Music was always a big part of life at Lomaland. The Raja Yoga School sponsored a number of very fine instrumental and vocal aggregations throughout the years. The Raja Yoga Orchestra (above), under the direction of Rex Dunn, is pictured in the rotunda of the academy. Below, the Raja Yoga College Marching Band is pictured outside the school building in the early 1920s. (Above, courtesy of the Phelan Collection.)

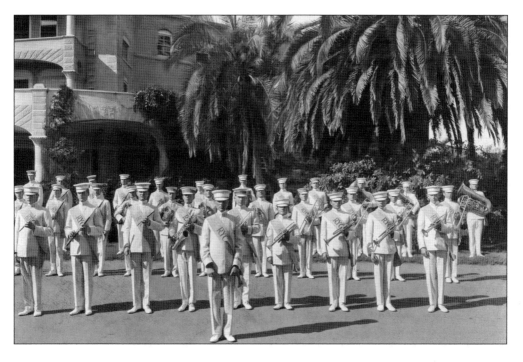

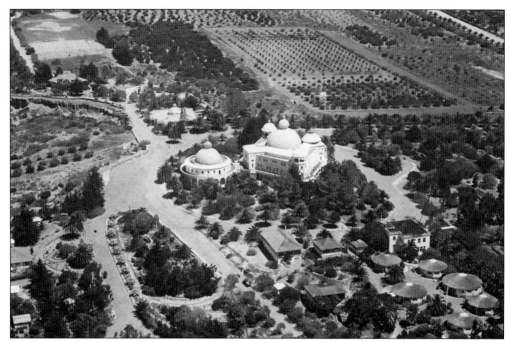

The Temple of Peace (left) and the Raja Yoga Academy building are centered in this aerial photograph of the Lomaland estate from 1910. The buildings in the lower right corner were student dormitories called group homes.

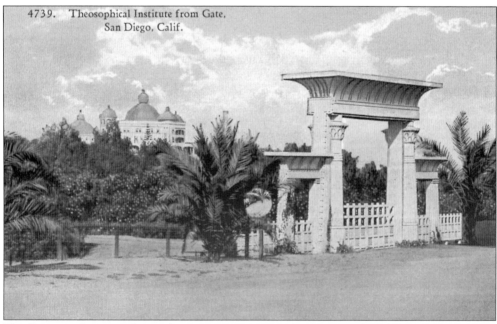

4739. Theosophical Institute from Gate,
 San Diego, Calif.

The Egyptian Gate was the southern entrance to Lomaland and marked the road to the Greek Theater. Today, this is the corner of DuPont Street and Catalina Boulevard. (Courtesy of the DuVall Collection.)

The doors of the Temple of Peace were carved by Lomaland resident and internationally renowned artist Reginald Machell in 1901. Among other symbols, the dog represents fidelity and the lilies purity. The doors, over 12 feet tall, are now in the collection of the San Diego History Center.

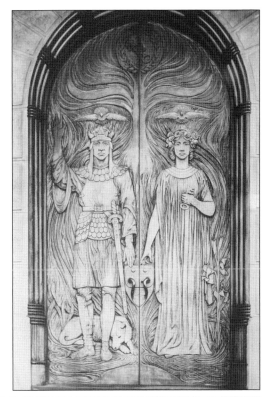

Built in 1905, Cabrillo Hall, on the campus of Point Loma Nazarene University, was at one time the home and headquarters of Madame Tingley. (Photograph by Eric DuVall.)

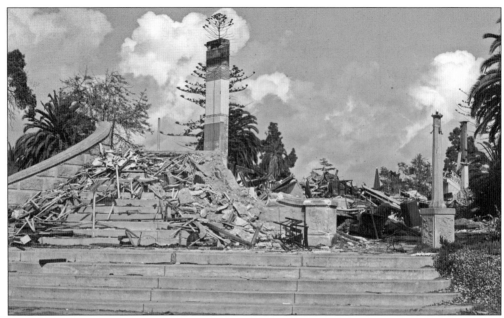

Following the death of Madame Tingley in 1929, the Theosophical community at Lomaland began to decline. Economic factors forced the sale of portions of the property during the 1930s, and the Theosophical Society eventually sold the remainder of the estate in 1942, moving its headquarters to Covina and later Pasadena. Following a fire in 1952, pictured above, the Temple of Peace was torn down. In the years since, the beautiful Lomaland campus has been home to Cal Western University and now Point Loma Nazarene University. Below, Raja Yoga schoolchildren walk to class in 1907. (Above, SDHC.)

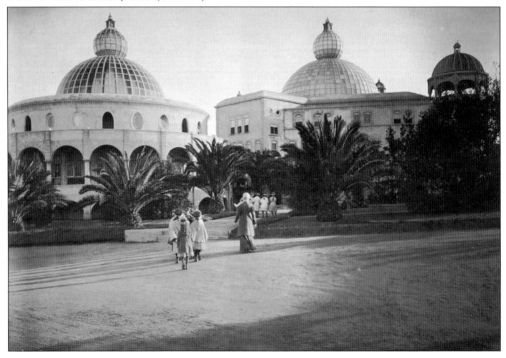

Five

A NAUTICAL WINDOW TO SEA AND BAY

Point Loma's historical link with the sea has been continuous since Spanish explorer Juan Rodríguez Cabrillo anchored off Ballast Point on September 28, 1542. He was greeted by the native Kumeyaay, who had occupied the area for thousands of years. Further interaction occurred in 1602 with the arrival of Sebastián Vizcaíno, whose cartographer sketched the first map showing Point Loma's position at the entrance of the "Puerto Bueno de San Diego." The first Catholic mass was celebrated on the shore of La Punta de los Guijarros (Ballast Point) on November 12, 1602, the saint's day of San Diego de Alcalá, assuring that the name would live on in the port, mission, city, and university.

Point Loma residents feel a deep connection with their region's nautical history. Spanish ships traveled between Mexico and California supplying goods to the mission fathers, while later hide and tallow traders arrived from Boston to carry manufactured products to Point Loma's La Playa area and the pueblo of San Diego. The Americans took over California in 1846 and built a lighthouse in 1854 to help ships navigate around the tip of Point Loma. The original lighthouse was poorly located, so a new lighthouse was built in a lower position in 1891. Also in 1891, the San Diego Yacht Club, founded in 1886, moved its headquarters to a building on Ballast Point, where it remained until 1898. It moved to La Playa in 1934.

As more people moved to San Diego after the beginning of the 20th century, both fishing and yachting off Point Loma increased. During World War I, local boating activities were curtailed while the US Navy patrolled the coastal waters off Point Loma. Because of the bay's strategic position, the Navy increased its interest in San Diego, and the bay was dredged in 1934 to provide a channel 200 feet wide and 20 feet deep. During World War II, sailors were confined to the bay. After the war, all restrictions were lifted, and Point Loma's fishermen and boating enthusiasts resumed regular activities. Today, a vibrant nautical scene is a highlight of Point Loma.

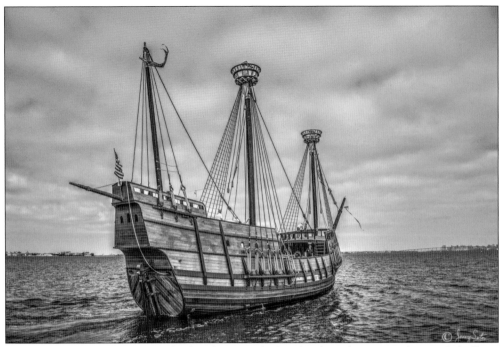

Pictured is a replica of the *San Salvador*, the Spanish ship that brought Juan Rodríguez Cabrillo to the bay he named San Miguel in 1542. The name of the bay was changed to San Diego de Alcalá by Sebastián Vizcaíno, who arrived on November 12, 1602. (Photograph by Jerry Soto.)

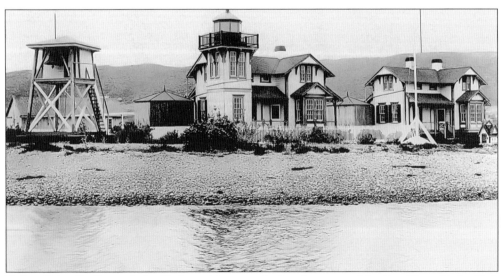

Ballast Point (La Punta de los Guijarros) became the headquarters of the San Diego Yacht Club in 1891. Today, Ballast Point lies within the US Navy submarine base. (SDYC.)

San Diego Bay is seen at Talbot Street in 1905. Today, Talbot Street runs from Tarento Drive to Anchorage Lane. (SDYC.)

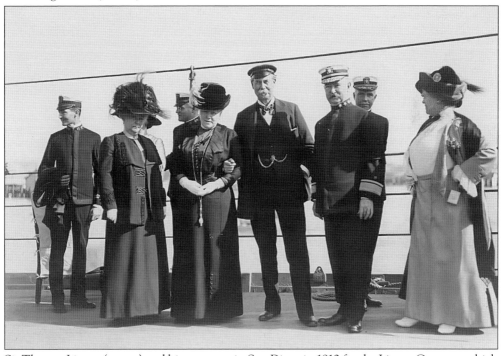

Sir Thomas Lipton (center) and his party are in San Diego in 1912 for the Lipton Cup race, which has been held annually in Southern California up to the present time. Both the San Diego Yacht Club and Southwestern Yacht Club have hosted the Lipton Cup race, which is sponsored by the club with the winning yacht. (SDYC.)

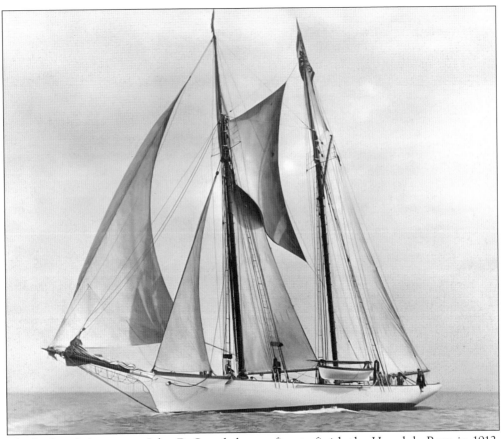

The *Lurline*, belonging to John D. Spreckels, was first to finish the Honolulu Race in 1912, carrying a pennant with red letters that read "San Diego 1915." Spreckels was a prominent San Diego businessman. (SDYC.)

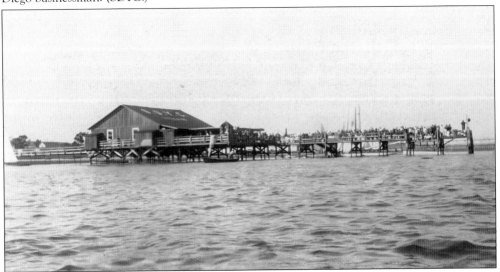

The San Diego Yacht Club is pictured in 1923 at the foot of Talbot Street. At the time, the club also had another location on Glorietta Bay in Coronado. (SDYC.)

Motorboats in the 151 class race off Point Loma around 1929. (SDHC.)

The San Diego Yacht Club building was literally moved from Glorietta Bay in Coronado to its present location on Point Loma. The move took place under the direction of Commodore Roy Hegg in 1934. (SDYC.)

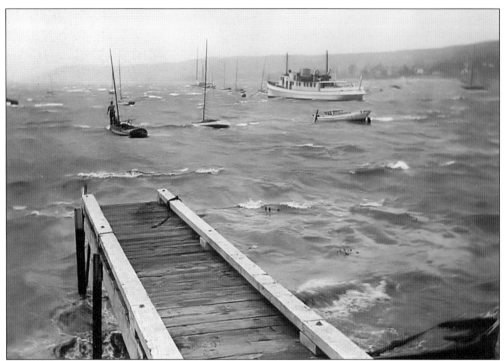

In 1937, a storm causing waves of near-tsunami proportions damaged docks all along Point Loma's shore and at the embarcadero. Similar waves damaged docks in 2011. (SDYC.)

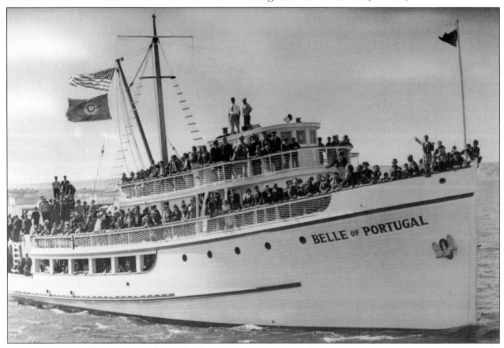

Tuna clipper *Belle of Portugal* was built in 1937 at Campbell Marine. Owned by the Manuel da Rosa family, it was converted into Navy vessel YP-321 during World War II. (Courtesy of the Zolezzi Family Collection, San Diego Maritime Museum.)

Milt Wegeforth traveled to Kiel, Germany, with his Star boat and crewman Barney Lehman to compete in the 1939 Star World Championship. He placed third and just made it home before the outbreak of World War II. (SDYC.)

Lowell North (center) and Malin Burnham (right) won the Star World Championship on Long Island Sound in 1945. (SDYC.)

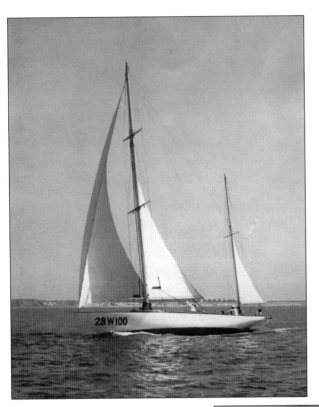

PCC-14 *Brilliant*, owned by Gartz Gould in 1944, shows the large identifying numbers on her hull during World War II. (SDYC.)

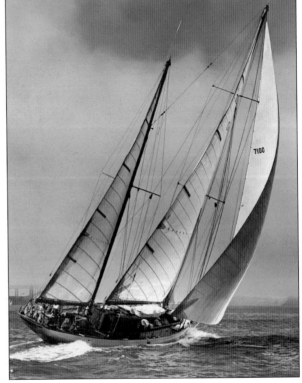

John Scripps's *Novia del Mar* is pictured during the 1960s with Point Loma in the background. On November 2, 1971, this 89-foot ketch burned and sank 25 miles north of Cedros Island as it was returning from the Newport–Cabo San Lucas race. (SDYC.)

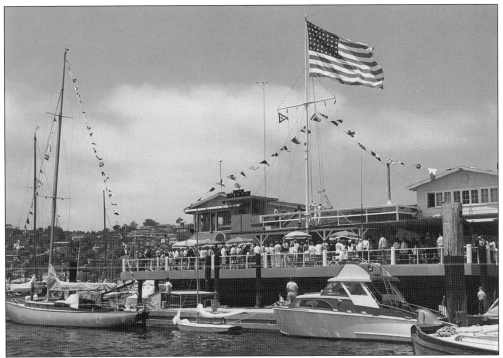

The flag is raised on opening day at the San Diego Yacht Club in 1949, and various boats are shown at the dock. (SDYC.)

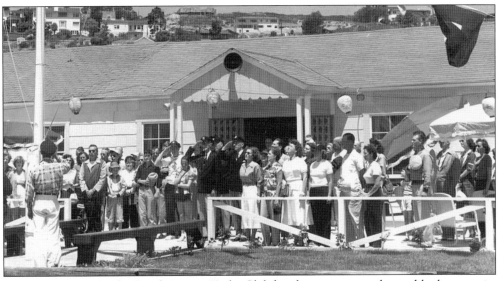

On March 27, 1951, the Southwestern Yacht Club headquarters was relocated by barge to its present site at the foot of Qualtrough Street and members celebrated opening day in their new clubhouse. (Courtesy of the Southwestern Yacht Club.)

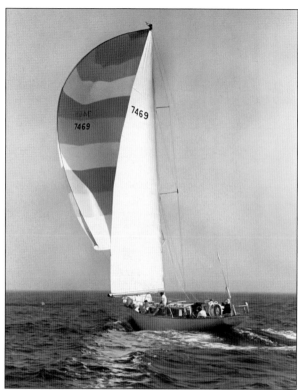

Brushfire, owned by Gene Trepte, competed in the 1971 Lipton Cup race. (SDYC.)

Swiftsure III took first to finish honor and Class A fleet place in the 1985 Transpac (Honolulu) Race. Local sailors pictured are, from left to right, (front row) Jerry LaDow, Bob Frazee, John Rumsey, and Art Ellis; (back row) Allen Crawford, Rob Maw, Nick Frazee, Gary Gould, Steve Taft, and John McClure. (SDYC.)

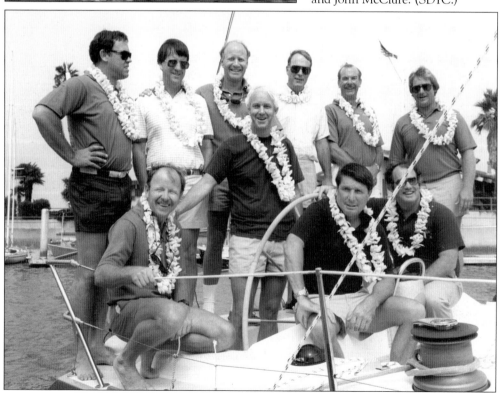

Mark Reynolds, winner of the gold medal in the Star class in the Barcelona Olympics in 1992 and in the Sydney Olympics in 2000, also won the Star World Championship in 1995 and in 2000. (SDYC.)

US Sailing Hall-of-Famer Dennis Conner (left) is pictured with Pres. Ronald Reagan. They are holding the America's Cup in this photograph autographed by the former president in 1992. (SDYC.)

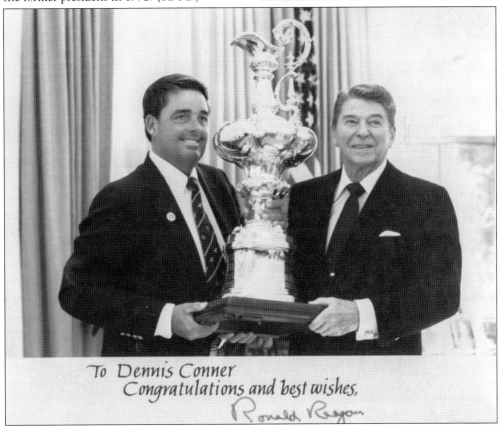

To Dennis Conner
Congratulations and best wishes,
Ronald Reagan

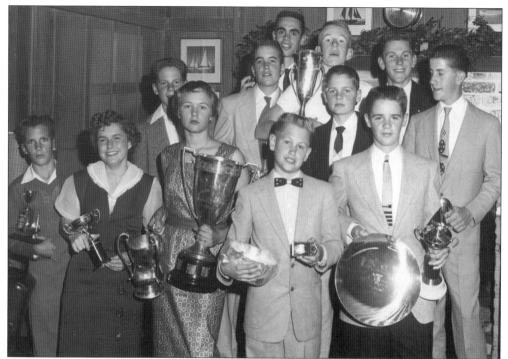

Junior yacht club members receive awards in 1956. Those pictured include Barbara Sinnhoffer, Steve LaDow, Pat Stadel, Gary Gould, Charlie Rogers, Hugh McLean, Paul Murill, Rob Maw, and Mike Town; Bruce Stadel (left) and Chris Town (right) are in front. (SDYC.)

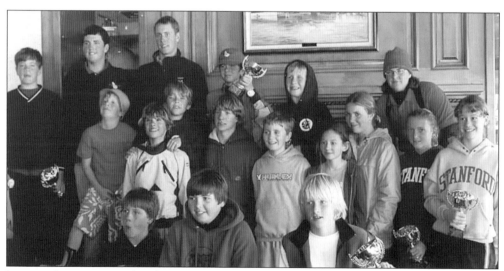

Junior sailors are pictured at the San Diego Yacht Club in 2006. They are, from left to right, (first row) Jake LaDow, Jake Reynolds, and Erick Cibit; (second row) Patrick Snow, Shone Bowman, Scott Sinks, Judge Ryan, Clayton Schluter, Georgie Ryan, Mallory Schluter, Marly Isler, and Emily Bohl; (third row) Nevin Snow, coach George Saunders, coach Graham Biehl, Matt Morris, Will LaDow, and coach Danielle Richards. (SDYC.)

The Silvergate Yacht Club was founded on Shelter Island in 1954, with anchorage in San Diego Bay opposite the Point Loma peninsula. (Photograph by Stuart Hartley.)

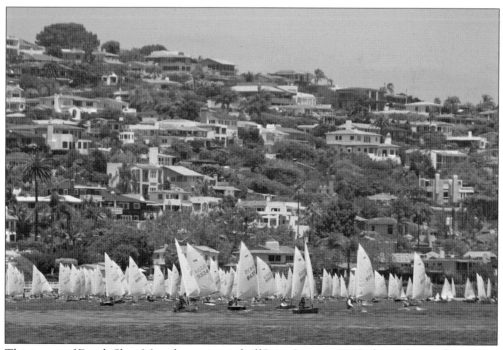

This image of Dutch Shoe Marathon, pictured off Point Loma in 2010, shows the number of new houses overlooking San Diego Bay. (SDYC.)

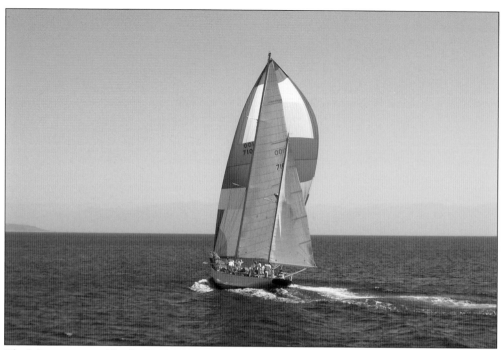

The *Miramar*, owned by the Paul Scripps family, is a veteran of numerous races to Puerto Vallarta, Acapulco, Hawaii, and Tahiti. (SDYC.)

In recognition of its contribution to worldwide sailing, the Star-class sailboat, winner of many world championships through the talent of Point Loma sailors, has a permanent home in the Hall of Champions in Balboa Park. (Photograph by Iris Engstrand.)

Six

LIFE ON THE POINT

Point Lomans have always been resourceful in finding ways to meet the needs of their developing community. Whether commissioning new churches to facilitate worship and religious traditions or advocating for the construction of libraries and schools to educate their youth, community leaders roll up their sleeves to bring about improvements that keep Point Loma a thriving and attractive neighborhood.

Portuguese immigrants began settling in La Playa in the early 1900s. Skilled in fishing and seamanship, they built the tuna industry in San Diego and left their mark on civic life. In 1908, they dedicated the first church in Point Loma, St. Agnes Catholic Church, and their children populated Roseville Elementary School, the first public school on the point. Their colorful annual *festas* have enriched cultural life on the peninsula.

Residents take pride in their area schools (public, private, and charter), which enjoy widespread support from active parent groups and service organizations. And Point Loma has been well served by the academic talent at the three universities that have called the Lomaland campus home over the past 60 years.

As Point Loma grew, citizens came forward to help shape the direction of development. Civic organizations such as the Point Loma Association continue to provide leadership to address problems associated with growth. Their beautification efforts have brought down unsightly billboards and telephone poles, tackled graffiti, and landscaped medians. Other philanthropic organizations and service clubs vigorously fundraise to benefit peninsula projects and assist youth groups.

Residents are tireless in their efforts to promote projects that enhance community life. Whether launching a summer concert series, artfully decorating utility boxes, or lining Rosecrans Street with flowering jacaranda trees, local leaders are knowledgeable about how to get things done. Partnering with city officials, Navy leaders, port personnel, and elected officials, dedicated Point Lomans continue working to improve the quality of life in the community they love.

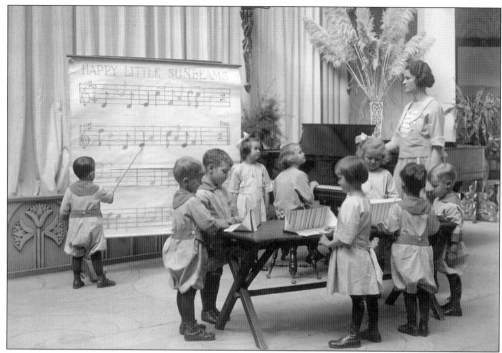

The Raja Yoga Academy established by Madame Tingley at Lomaland offered general education for children of families living in Point Loma. It soon developed into a boarding school for over 300 students, offering instruction from the primary grades through advanced graduate studies. Musical training was required of all students, resulting in a school orchestra that gave professional concerts. Here, students learn to read music and practice keyboard fingering under the tutelage of teacher Judith Tyberg, PhD. (Courtesy of the Theosophical Society, Pasadena.)

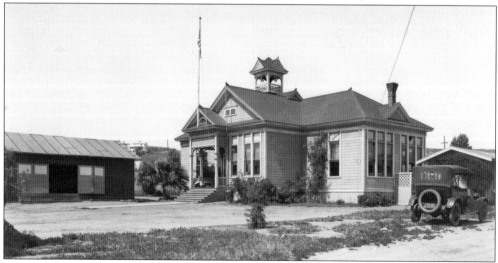

Opened in 1906, Roseville School was built by Sheriff Frank Jennings on Byron Street in Point Loma. In 1921, Roseville School was replaced by Point Loma Elementary School on Talbot Street to serve kindergarten through eighth grade. When Point Loma High School opened in 1925, Point Loma Elementary became Cabrillo School to avoid confusion with the high school and to honor the Spanish explorer who discovered San Diego Bay. (SDHC.)

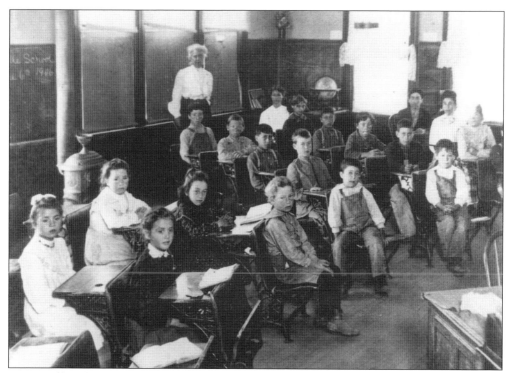

A Roseville School classroom is pictured around 1906. The school hired two bilingual teachers to work with the sizable population of Portuguese-speaking students whose fishermen parents settled in the La Playa area. (SDHC.)

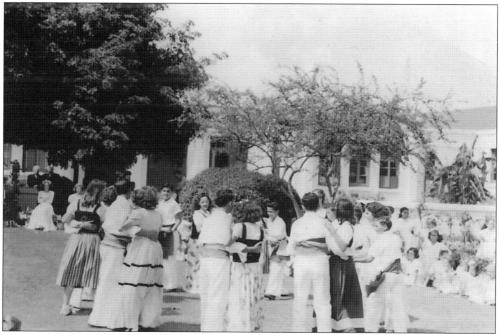

Sixth-grade students perform the Chamarita, a Portuguese folk dance, at the Cabrillo School Spring Festival in 1947. (Courtesy of Olivia Rosa Ledbetter.)

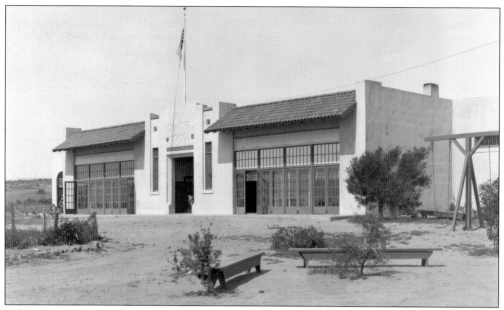

When George Burnham built a home in the newly developed residential area of Loma Portal, he was unhappy that his six children had to commute to the overcrowded Roseville School and sought to have a new school built in Loma Portal. A new two-room stucco building opened in 1914, welcoming 18 students in grades one through eight. (SDHC.)

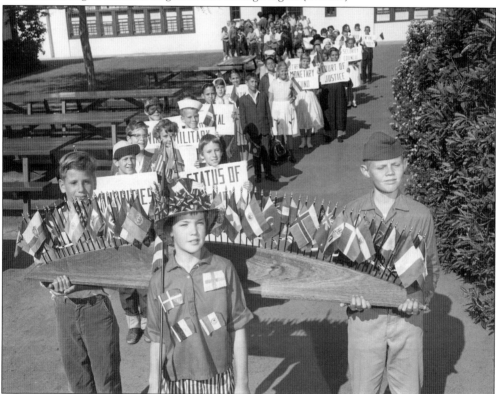

Loma Portal Elementary students celebrate United Nations Day around 1960. (SDHC.)

Silver Gate Elementary opened in 1951 to serve the burgeoning number of young families drawn to the neighborhood by its proximity to the city and marvelous views of the ocean and bay. Built on a site that was originally home to an orchard, the school was to be called Orchard School. However, since the site also overlooked the entrance to San Diego harbor, dubbed the "Silver Gate to San Diego," the school was renamed Silver Gate Elementary. (Courtesy of the San Diego Unified School District.)

A Silver Gate Elementary School classroom is pictured around 1952. (Courtesy of the San Diego Unified School District.)

Named for its location overlooking the Pacific Ocean, Sunset View Elementary was built on three levels scooped out of the moderately steep Point Loma hillside. Built in 1954, it replaced the old, inadequate Azure Vista School in the wartime federal housing project on Sunset Cliffs. Here, students from Azure Vista School take a field trip to get a glimpse of their newly constructed school. (Courtesy of the San Diego Unified School District.)

Nellie Walker founded her private school in 1932, holding her first class above state senator Fred Kraft's drugstore on Bacon Street in Ocean Beach. By 1939, she had moved a beach cottage from Santa Cruz Avenue to Warren-Walker School's present site on Point Loma Avenue. Soon, the enrollment outgrew the cottage, and many buildings were added to accommodate today's 173 prekindergarten through fifth-grade students at Point Loma's lower school campus. Here, Warren-Walker students perform the traditional maypole dance to celebrate May Day—a yearly tradition. (Courtesy of Warren-Walker School.)

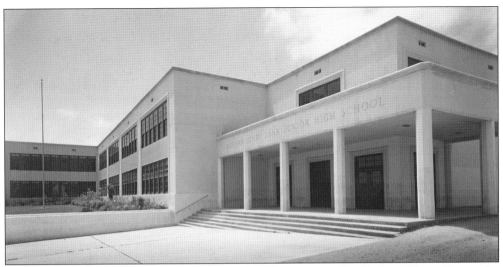

Dana Junior High was built in 1942 and named for American author Richard Henry Dana, who wrote *Two Years Before the Mast.* During the 1940s and 1950s, the school doubled as a Cold War–era bomb shelter. Closed in 1983 because of declining enrollment, Dana was resurrected as a middle school in 1995, when there was a shortage of classrooms in the Point Loma community due to a reduction in classroom sizes and an influx of students from the 500-unit Navy housing project built at NTC. (SDHC.)

High Tech High, the first charter school to locate in Point Loma, opened in 2000. Civic and high-tech industry leaders, concerned about the challenge of finding qualified individuals for high-tech work and the "digital divide" that kept women and ethnic minority groups from entering science, technology, engineering, and mathematical fields, sought to establish a school where students would learn the skills necessary to succeed in the 21st-century workplace. Students are accepted by a blind zip code–based lottery. (Courtesy of High Tech High.)

Point Loma Junior-Senior High School, the third-oldest high school in the San Diego Unified School District, was dedicated in 1925 to serve grades 7 through 12. With the opening of Dana Junior High School in 1942, Point Loma became a three-year high school. Today, the campus serves

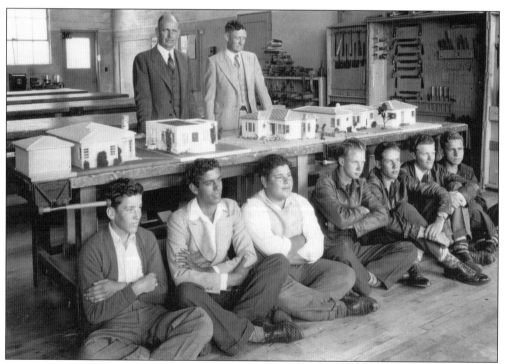

Point Loma High principal Clarence Swenson (left) and technical arts instructor George Rye (right) pose with students and their architectural models around 1939. (Courtesy of the Ocean Beach Historical Society.)

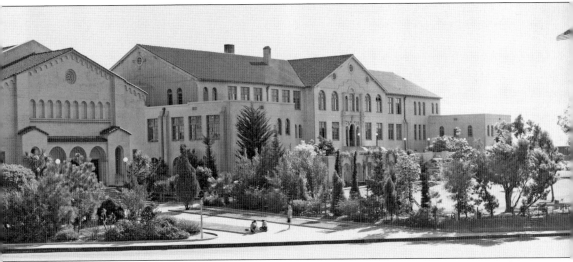

grades 9 through 12. The original three-story building was demolished in the 1970s as part of the Field Act Earthquake Safety Program. Plans are underway to restore the campus to its previous Spanish architectural splendor. (Courtesy of the Ocean Beach Historical Society.)

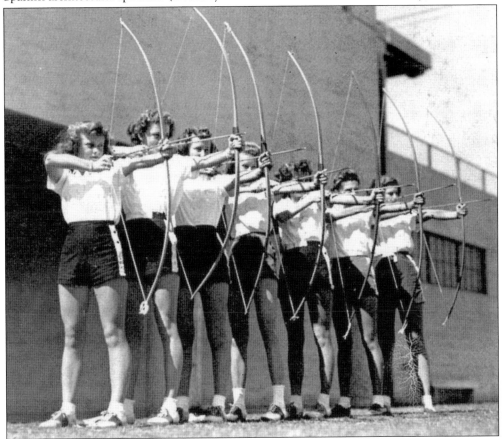

Attired in gym uniforms, Point Loma High girls learn archery in a physical education class in 1945. (Courtesy of the Point Loma High School Alumni Association.)

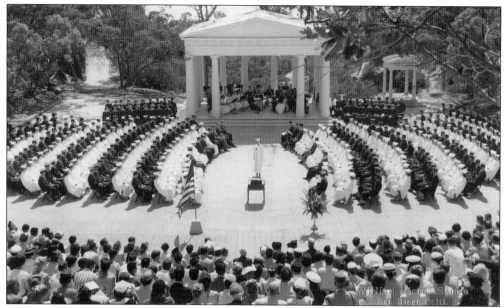

Lomaland, the name associated with Katherine Tingley's Theosophical commune, has been home to several institutions of higher education, including California Western University in 1952. Renamed United States International University, the school moved to the Scripps Ranch area in 1968. The California Western School of Law relocated to downtown San Diego from Lomaland in 1973, paving the way for Pasadena College's move to the campus to become Point Loma College. The school was renamed Point Loma Nazarene University in 1998. All of the universities have enjoyed the use of the Greek Theater as a scenic graduation venue. Here, Point Loma High School's class of 1956 holds graduation ceremonies at the Greek Theater. (Courtesy of Linda Fox.)

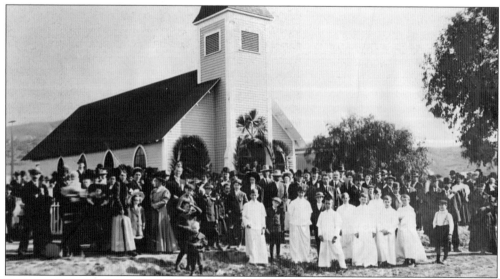

Built in 1908, St. Agnes Catholic Church became the first church in the Roseville area and provided the Portuguese community a place to worship. A mission church, it shared a pastor with Mary Star of the Sea in La Jolla and the Old Town Church. It formally became a parish in 1933 with the arrival of Fr. Manuel Rose from Portugal. (Courtesy of St. Agnes Church.)

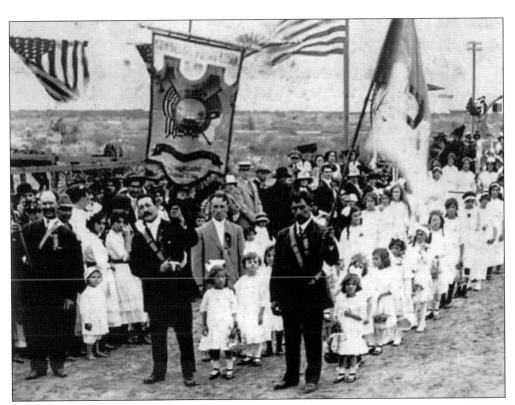

The Festa do Espirito Santo (Feast of the Holy Spirit) is the oldest religious celebration in San Diego, dating back to the arrival of the first Portuguese families who settled here. Since 1922, Portuguese descendants of those families have paraded from the chapel (*capela*) adjoining the United Portuguese Sociedade do Espirito Santo (UPSES) Hall to St. Agnes Church for a celebratory mass, followed by another procession back to the hall. The chapel was built to hold the Holy Spirit Crown during the festa. The annual festa draws spectators from throughout the community who line the parade route to enjoy the colorful procession and lavish costumes worn by the queen and her court. (Above, courtesy of the Portuguese Historical Center; right, courtesy of SDHC.)

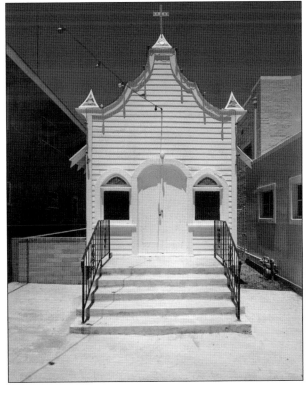

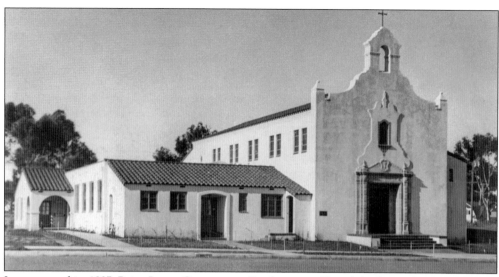

Incorporated in 1937, Point Loma Community Presbyterian Church had 133 charter members, who initially gathered for worship at Point Loma High School. Within a year, the fledgling congregation found a home for its church on lots purchased near Chatsworth Boulevard and Voltaire Street, where it built a Mission-style chapel. Classroom facilities were added in 1948, and a new sanctuary was completed in 1954 to accommodate the flourishing membership. "The Red Brick Church" celebrated its 75th anniversary in 2012. (Courtesy of Point Loma Community Presbyterian Church.)

Westminster Presbyterian Church, organized in 1952, leased the Point Loma Assembly Hall for church services until the present site at the corner of Talbot and Cañon Streets was purchased for $15,000 from David Fleet of Fleetridge fame. In 1955, the congregation moved into its new building, which served as sanctuary, classrooms, office, fellowship space, and theater. Five years later, ground was broken for a new sanctuary, and the congregation acquired additional land for a community park, part of which today has been transformed into a community garden. (Courtesy of Westminster Presbyterian Church.)

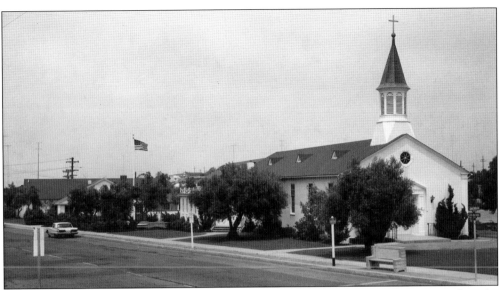

In the years following World War II, San Diego burst with development to accommodate the new population who had come here for war-factory work and military service. Point Loma, with sweeping views of San Diego Bay and the Pacific Ocean, was a popular site for new housing. With these new residents came the need to establish a new Episcopal parish, All Souls' Church. In 1949, the parish acquired land at the intersection of Catalina and Chatsworth Boulevards to house a surplus chapel moved to the site from a decommissioned Army camp nearby. It served as the sanctuary until the present church was built in 1965. In the photograph below, children, parishioners, and clergy participate in dedicating the new Sunday school and administration building in 1957. (Both, courtesy of All Souls' Episcopal Church.)

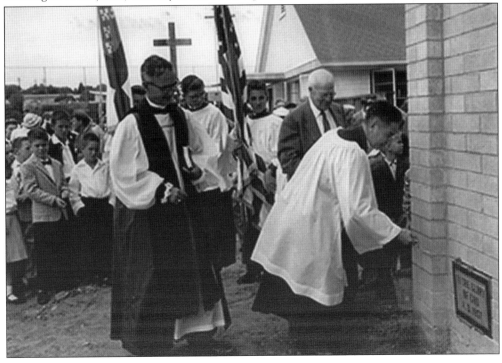

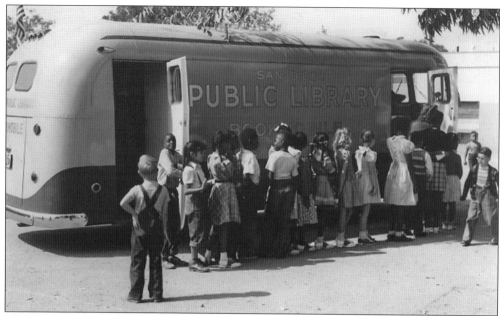

Prior to the expansion of branch libraries, many San Diego neighborhoods were served by the San Diego Public Library's bookmobile. Launched in 1948, the first bookmobile brought library services to schoolkids and patrons at elementary schools and shopping centers throughout San Diego. Cabrillo School students eagerly awaited the weekly visits at the corner of Upshur and Rosecrans Streets, where they could browse the 2,000-book collection within the 23-foot-long van. (Courtesy of Special Collections, San Diego Public Library.)

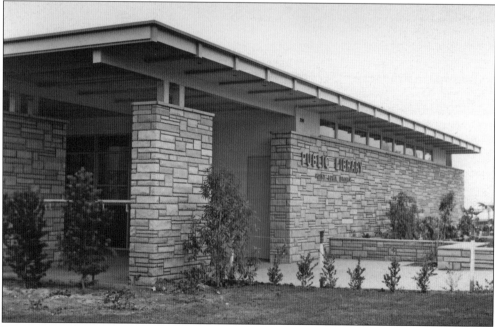

Point Loma's first branch library, built at the corner of Poinsettia Drive and Udall Street, was dedicated in 1959. It served the community for 54 years until it was replaced on the same site by the Point Loma/Hervey Branch Library in 2003. (Courtesy of the San Diego Public Library.)

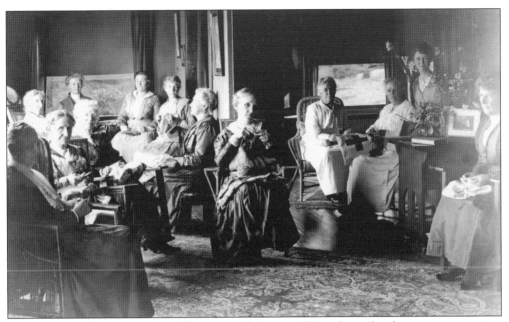

Twenty-eight ladies of Point Loma (then Roseville) met in 1911 to form a local improvement society to aid in the growth and improvement of Point Loma. Incorporated as Point Loma Assembly, they made plans to build a clubhouse. Frank Jennings offered to let them lease a lot at the corner of Talbot Street and Armada Terrace for 30 years for a penny a year. After three years of fundraising, the clubhouse was built, with Jennings paying 10 percent of the building cost. (SDHC.)

Dedicated in 1915, the Point Loma Assembly clubhouse has been the headquarters for the group's educational, social, and charitable work for over a century. The assembly building has also served as a venue for a variety of community functions including civic meetings, a Red Cross workroom during World War II, a school auditorium, election polls, a city library depot station, plays, and parties. (Photograph by Stuart Hartley.)

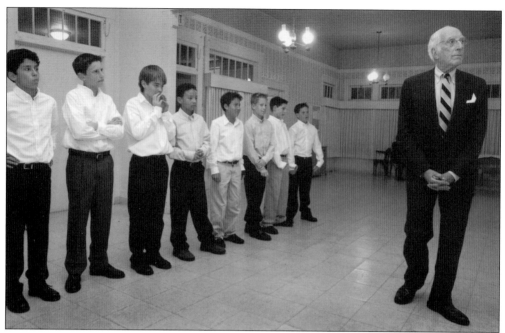

Donald A. Benjamin, equal parts Fred Astaire and Emily Post, stands near boys awaiting his instructions in a social graces and dance class held at the Point Loma Assembly clubhouse. A rite of passage for sixth-grade students, "Mr. Benjamin's" classes were part dance step mastery and part etiquette boot camp. (© Howard Lipin/UT San Diego via ZUMA Wire.)

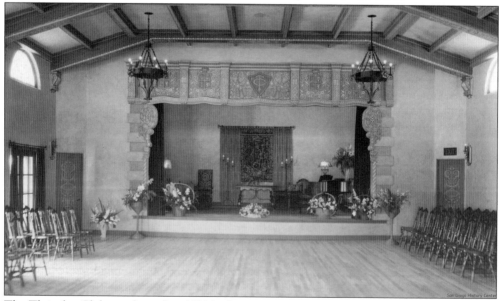

The Thursday Club was formed in 1921 by four community-minded young women who wanted a club that would combine social activities with worthwhile civic and benevolent projects. Granted a deed to a choice piece of land above Sunset Cliffs in 1927, the club was able to build a distinctive clubhouse. With its timeless Spanish architecture and breathtaking ocean views, the clubhouse is a popular event venue, the site of many wedding receptions in its attractive and spacious main hall. (SDHC.)

Few organizations have had as much impact in beautifying and improving the community as the Point Loma Association. When the organization was formed in 1964 as Point Loma Village Beautiful, Rosecrans Street was home to 11 giant billboards and 10 gas stations and was arrayed with overhead power lines and poles that ran the entire length of the thoroughfare. The group led the effort to remove unsightly signage and billboards and to bury power lines underground, two projects that vastly improved the appearance of the village. (Courtesy of the Point Loma Association.)

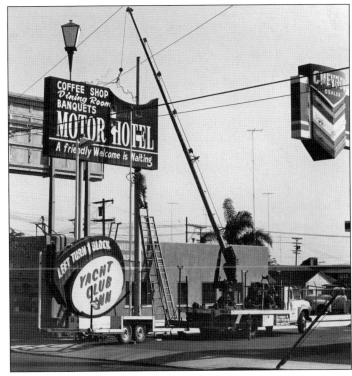

Today, members work tirelessly on graffiti abatement, neighborhood beautification, and many other improvement efforts. The Mean Green Team is well known and appreciated for its weekly gardening and cleanup sessions that keep over 18 public areas in Point Loma well landscaped. (Courtesy of the Point Loma Association.)

Point Loma has been well served by several longtime service clubs. A long-standing project of the Point Loma Optimist Club has been posting American flags the length of Rosecrans Street, from Lytton Street to Talbot Street, every Sunday and on special holidays. Members take turns volunteering to post and take down the flags from the club's Flag Car. (Courtesy of the Point Loma Optimist Club.)

On five summer evenings in July and August, families pack their chairs, blankets, and picnic baskets and head to Point Loma Park to rock out to the sounds of popular big-name bands. Young musicians from the community perform on the Junior Stage before the main event, and proceeds from raffle sales are donated to youth music education programs in the Point Loma area. (Photograph by Cynthia Sinclair.)

Seven

BUSINESS BY THE BAY

The very earliest commercial activities on Point Loma were opportunistic and simple. Taking advantage of the shallow waters around La Playa, Native Americans gathered shells for trading. Otter pelts and seal furs were gathered by itinerant Mexican hunters. Cowhides were processed inland and transported to the beach. On the shore, whale blubber was rendered into oil. The men involved in this trading, and the details of their lives along the bay, are described in the first chapter of this book.

Later commercial activities on the Point Loma peninsula can be divided into two types: those that depended on the community's location on San Diego Bay, and those that served the people who lived in or visited the area but were not related to the nearby harbor. The first category includes fishing and fish processing, shipping, boatbuilding, tourism, and seaside recreation. The second category is made up of enterprises that develop anywhere people settle: stores, restaurants, transportation providers, and hotels. Despite the hopes of its early real estate developers, with the exception of fish and sardine canneries, the area never became home to large industrial concerns. The result today is a beautiful and clean bayfront community nestled between military bases and the sea.

Europeans like Louis Rose who bought land for development on Point Loma emphasized its location closer to the mouth of San Diego Bay than San Diego and other settlements and hinted at the commercial advantage of this site. Their earliest business ventures were stores and hotels. Later, physical changes to the shoreline related to dredging and reshaping San Diego Bay created opportunities for tourism and the ocean-oriented commerce that followed.

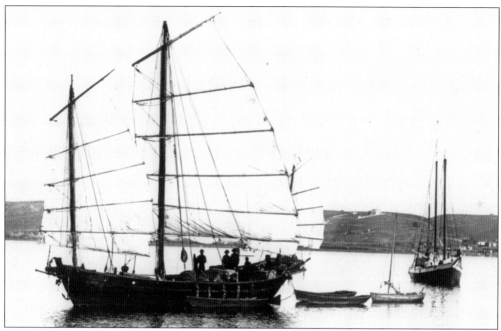

Chinese who built boats known as junks settled at Roseville in 1869. The *Sun Yun Lee* was the largest, built in 1884. Its rounded bottom was created by heating and bending redwood boards bought in nearby San Diego. The Chinese of Point Loma were known as the finest junk builders in California. (Courtesy of the Chinese Historical Society of Southern California, Nash Collection.)

Portuguese fishermen took advantage of the rich schools of sardines and mackerel in San Diego Bay. This small wharf with storage buildings at Roseville was the headquarters of their fishing operation. Later, when a method of canning albacore was developed, these fishermen expanded both the size of their boats and the business of commercial fishing. (SDHC.)

Around 1911, Jose Azevedo and other Portuguese leaders created the San Diego Packing Company to can sardines. The cannery is on the right in the background, and on the left is the small Portuguese fishing wharf. In the foreground, an early Festa do Espirito Santo procession is underway. It is still celebrated annually by Portuguese in Point Loma's Roseville community. (SDHC.)

In 1926, the tuna clipper *Atlantic* was the largest and most advanced boat in the fleet. Five years later, clipper size doubled when the *Mayflower* was launched. Capt. Manuel Medina built the *Atlantic* and was part-owner of the *Mayflower*. This 1931 image was carefully folded and kept in the wallet of a Japanese tuna fisherman. (Courtesy of the Japanese American Historical Society of San Diego.)

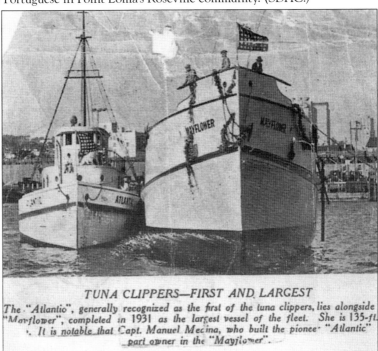

TUNA CLIPPERS—FIRST AND LARGEST

The "Atlantic", generally recognized as the first of the tuna clippers, lies alongside "Mayflower", completed in 1931 as the largest vessel of the fleet. She is 135-ft. It is notable that Capt. Manuel Medina, who built the pioneer "Atlantic" part owner in the "Mayflower".

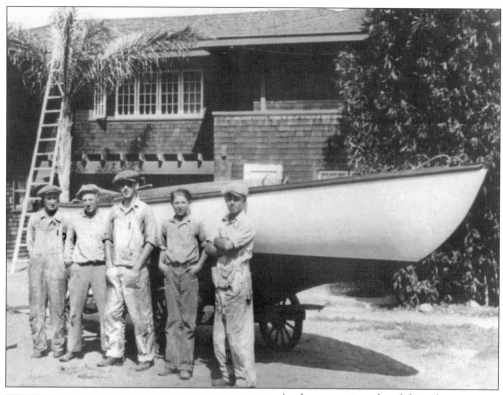

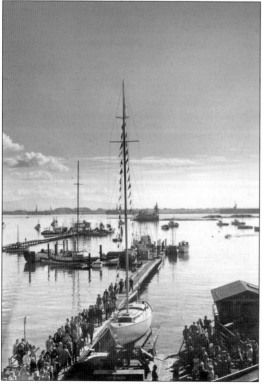

At the same time that fishing boats enjoyed easy mooring at Roseville, recreational boating along Point Loma was also growing. The Kettenburg family started building small boats on land and launching them behind their home at La Playa (above). Later, as harbor dredging gave form to Shelter Island, Kettenburg established its boatyard there (left). In the upper right of this 1946 image, two former World War II munitions bunkers still exist on low-lying Shelter Island. (Both, courtesy of the Maritime Museum and the Kettenburg family.)

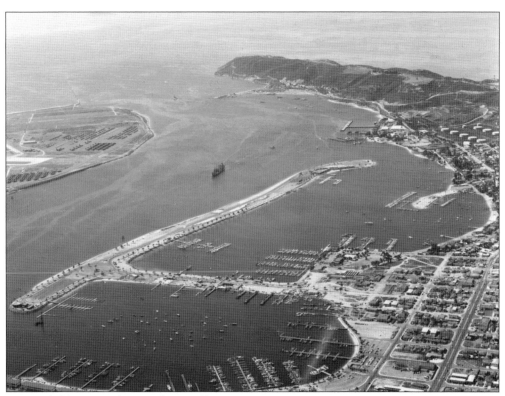

Boatyards like Kettenburg and Driscoll and other businesses serving maritime needs were first established along the causeway connecting the sandbar to Byron Street. By 1953, businesses were allowed to build on Shelter Island itself. One of the first, on the north end, was Christian's Hut. The Baumann family later transformed it into the Bali Hai, which is still in business today. (SDHC.)

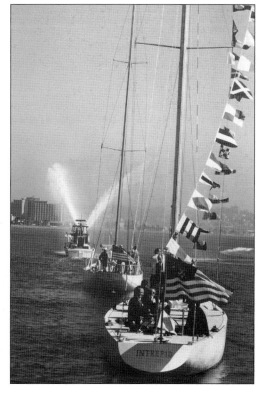

The Driscoll brothers set up their boatyard on the Byron Street mole in 1948 to build custom boats. By 1973–1974, they had become known for redesigning and repairing sailing vessels, and Gerry Driscoll skippered the redesigned *Intrepid* in the 1974 America's Cup trials. Net tenders and small tuna boats were the workhorse boats designed and built by the firm. *Intrepid* is shown at right on a trial run in San Diego Bay. (Courtesy of Driscoll Boat Works.)

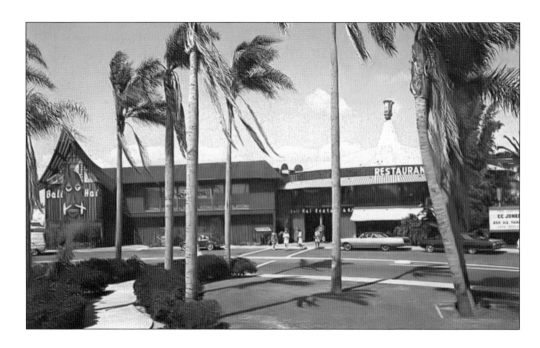

Beginning with the Bali Hai in 1953, a Polynesian "tiki" architectural theme began to take hold on Shelter Island and quickly spread throughout the surrounding area. The soaring roofline of the Half Moon Inn, built in 1961, and the liberal addition of palm trees and tropical plants added to this cultural phenomenon. Tiki images are still found nestled in the nooks and crannies of Shelter Island. (Both, images on postcards courtesy of David Marshall, AIA.)

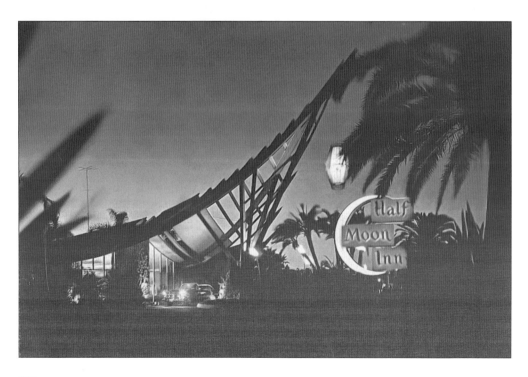

Established in 1938, Koehler Boatyard originally built a popular line of mahogany sport fishing boats and racing runabouts. The yard moved to newly formed Shelter Island in 1952 and constructed the San Diego Port Authority's first patrol and rescue boat. (Photograph by Iris Engstrand.)

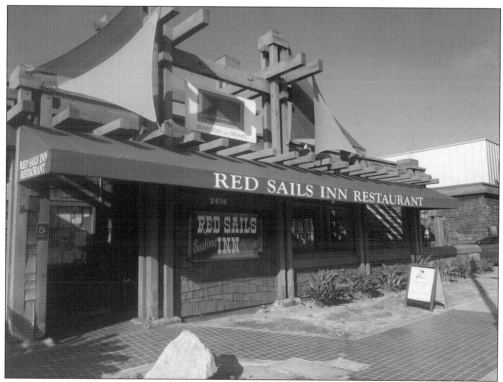

Red Sails Inn was started on Shelter Island in 1952 by local aviator and entrepreneur Jack Davis. Dating from the 1920s, Red Sails was first located at the foot of G Street, close to the Coronado–San Diego Ferry Landing. Point Loma shipwrights and sailors fondly recall the 50¢ abalone sandwiches in the early days. (Photograph by Iris Engstrand.)

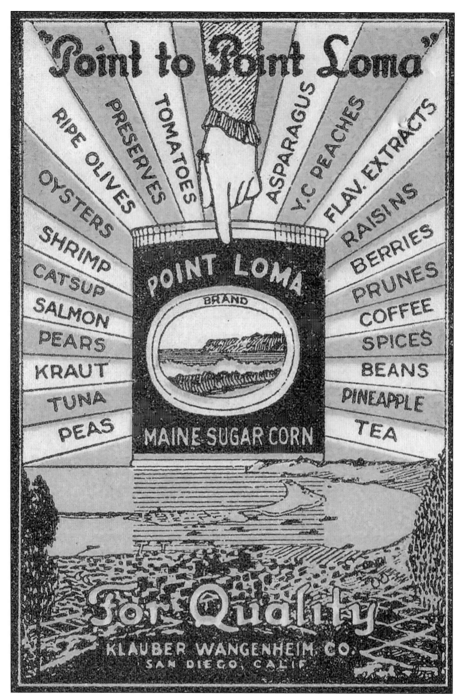

In 1886, partners Abraham Klauber and Simon Levi registered the "Point Loma" brand to use on their premier line of canned goods. The peninsula was visible from their San Diego warehouse. The label shown here dates from 1910–1920, and although it shows a more developed San Diego, the peninsula is still prominent in the image. During World War II, the Klauber Wangenheim Company sponsored victory gardens in Point Loma and throughout San Diego. (Courtesy of the Klauber Archives, D.M. Klauber.)

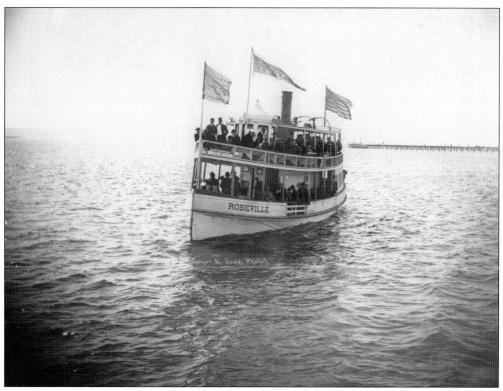

Mudflats separating the peninsula from the population centers in San Diego made surface transportation in the early days nearly impossible. The small steamer *Roseville*, shown above, was the earliest public transportation to Point Loma. Her destination was the wharf at Roseville near the San Diego Nail and Iron Works, shown on the right side of the image below in 1889. Built by Charles Bessemer as a nail factory, San Diego Nail and Iron Works later produced wire screens. (Both, SDHC.)

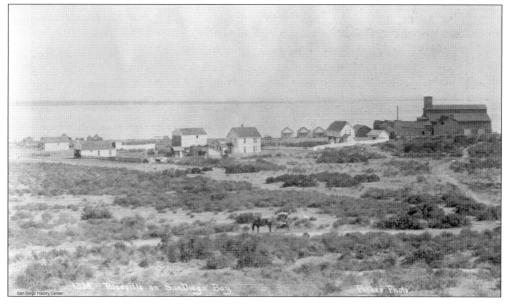

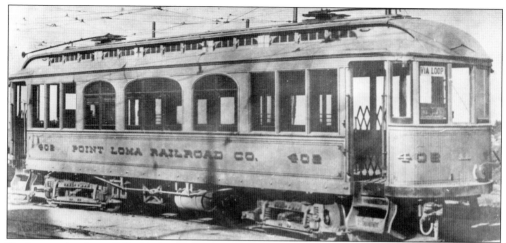

Real estate developer Billy Carlson attempted to build a train line across Point Loma from Roseville to Ocean Beach during the 1880s boom period, but it was not until 1908 that D.C. Collier's Point Loma Railroad Company conquered the mudflats and regular rail service was available. (Courtesy of the Ocean Beach Historical Society.)

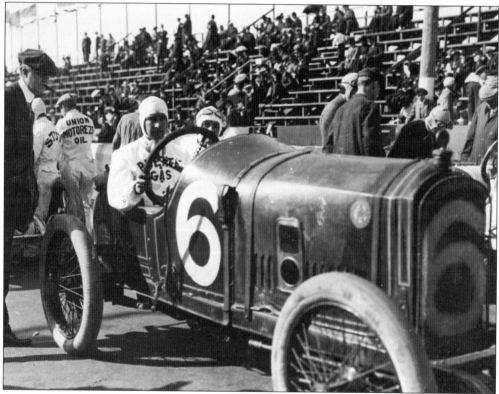

In January 1915, just after the Panama-California Exposition opened, Point Loma was the site of a major road race featuring international champions. The start/finish line was framed by 6,000 bleacher seats and located along Rosecrans Street from Dumas to Goldsmith Streets. (Courtesy of the Dan Abbott Collection, Panama-California Exposition Digital Archives.)

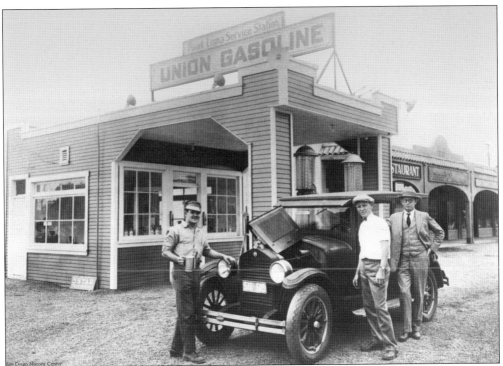

Point Loma had a small commercial district developed near the intersection of Rosecrans and Cañon Streets. This Union gas station sold gasoline products and tires. Shown here in 1925, the prime corner location on Rosecrans Street, owned by the Lovett and Sherman families, also housed a general store. (SDHC.)

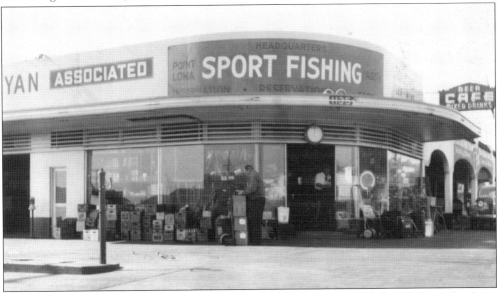

Sportfishing is another of Point Loma's ocean-dependent businesses. Before Shelter Island was completed, sportfishing stands like the one seen here at Rosecrans and Addison Streets were common sights in Point Loma. Later, the sport boat operators relocated to the commercial basin around Scott Street and Shelter Island Drive near the present America's Cup Harbor. (SDHC.)

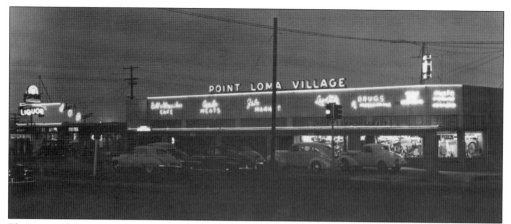

Elements of this neon-lit corner of Rosecrans and Addison Streets still remain: the liquor store is now known as the Village Store, and there is still a Shelter Island drugstore on the opposite end of the building. Old familiar businesses like Cecil's Meats and Zel's Market are long gone. (SDHC.)

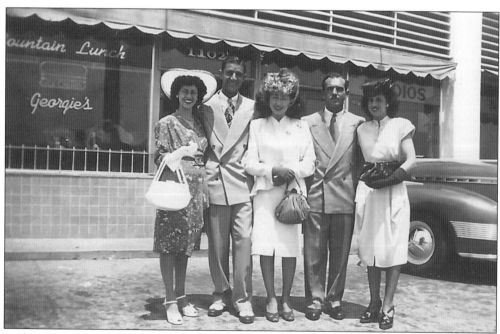

In the 1950s, after church, it was common to drop by Georgie's Fountain Lunch. Next door was Frank Rose's Merit Variety Store, where many locals both worked and shopped. These well-dressed women with their beaux are, from left to right, Lucy Brenha, Hazel Virissimo, Mary Brenha. (Courtesy of Virginia Correia.)

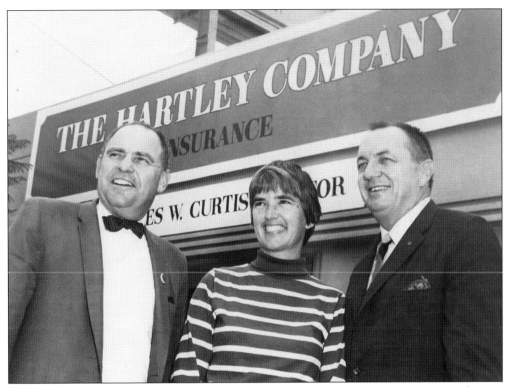

The Hartley family has a long history in San Diego County dating to their fire insurance salesman great-grandfather, who arrived from Iowa in 1882. San Diego congressman Bob Wilson (right) joined Donald J. Hartley Sr. and his wife, Lois, in 1968 in front of their business on Rosecrans street, which was established in 1951. (Courtesy of the Hartley Company.)

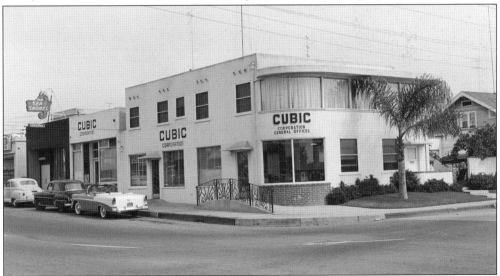

Founded by Walter J. Zable in 1951, Cubic Corporation began as a small electronics company in Point Loma. Cubic is now a global company in the transportation and defense industries with a presence in nearly 60 countries. The photograph shows Cubic's building at 2841 Cañon Street in 1956. (Courtesy of Cubic Corporation.)

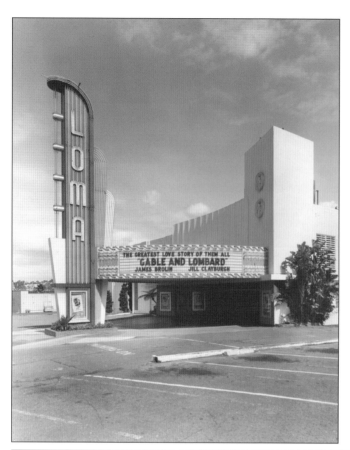

The Art Deco Loma Theatre was built in 1946 and was a favorite place to go on a date. It got all the first-run shows, including *Gable and Lombard* in 1976. By the late 1990s, it was failing as a movie house but obtained a new lease on life when it received a historic designation and Bookstar converted it to a bookstore. Its historic status allows no changes to the outside. (Left, SDHC; below, photograph by Daniel Soderberg.)

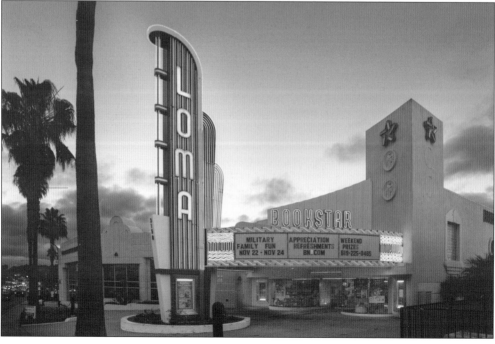

Eight

MONUMENTS AND PARKS

Some of Point Loma's history can best be told through the many monuments and memorials that recognize some of its most significant events and personalities. Many of these are found in neighborhood parks where residents and guests enjoy recreation. There are more than 80 registered national, state, and city historic landmarks and some 400 sites of historic interest on Point Loma.

The first Point Lomans were native Kumeyaay; then came Spanish priests and soldiers, Mexican rancheros, British explorers, fur trappers, Boston-China traders, Portuguese whalers and fishermen, American cowboys, railway men, the US cavalry, Chinese fishermen, and a myriad of adventurers who left records here. Soon after the founding of the San Diego Historical Society in 1929 and construction of the Serra Museum at the former presidio site, historians began a drive to define and mark Point Loma's old commercial route, known as La Playa Trail. These trailblazers included John and Winifred Davidson, architect Richard Requa, and others.

The original natural tidelands of San Diego Bay consumed beachfront as far west as Scott Street, and, in places, Rosecrans Street in Point Loma. In the 1940s, harbor dredging deepened the channel of San Diego Bay, and dredging materials were used to fill in those shallow tidelands along La Playa, thereby removing the original beach path.

The Lay Playa Trail was first defined in the early 1930s with six concrete markers decorated with a bas-relief of an Indian and a Mexican *carreta* (or oxcart). These six monuments were placed at significant points along the old route.

Over the decades, monuments and memorials have been placed in parks and open spaces by industry, private associations, the City and County of San Diego, and public-spirited individuals to help citizens remember a treasured past on the peninsula of Point Loma.

Cabrillo National Monument was established in October 1913 to commemorate the first recorded European vessel to reach the west coast of America. Visitors in the mid-1950s pose at the tribute to explorer Juan Rodríguez Cabrillo. Below, the first Cabrillo statue was donated to the National Park Service in 1949. The Portuguese government had intended for the statue to be celebrated at the 1939 Golden Gate International Exposition in San Francisco, but it arrived too late. The statue stood beside the old lighthouse until 1966. A second statue replaced the first due to erosion. Cabrillo's statue now stands on its own promontory at Cabrillo National Monument, beckoning visitors to the route of Cabrillo's expedition into what became known as San Diego Bay. (Left, courtesy of Kim Fahlen; below, courtesy of Cabrillo National Monument.)

Bayside Trail traverses the lee side of Cabrillo National Monument. The two-and-a-half-mile trail is an early-20th-century Army road connecting shoreside Fort Rosecrans with the 1855 lighthouse topside. Army soldiers used the lighthouse as a crow's nest, where they watched for ships at sea. Bayside Trail is one of the most scenic hikes in town. (Photograph by Kim Fahlen.)

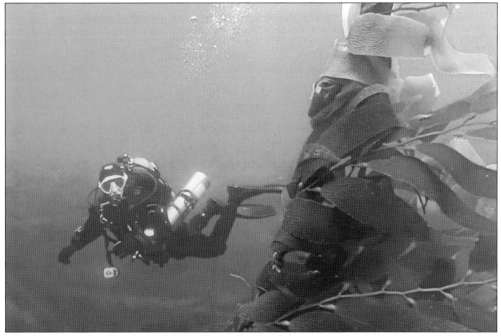

The Point Loma Kelp Forest is located windward of the peninsula and is designated on early nautical charts as a sign of dangerous shoreline reefs. Today, it is a federally protected area and a wonderland of sea life for whale watchers, divers, fishermen, kayakers, and sailors. (Photograph by Mike Bear.)

El Desembarcadero was Old San Diego's anchorage for nearly a century from 1769 until the 1860s. In April 1829, Dona Josepha Carrillo and the Boston sea captain Henry Delano Fitch eloped from here. Josefa's cousin, future governor Pio Pico, carried her on horseback down the La Playa Trail to the anchorage where the lovers met and sailed for South America. (Photograph by Kim Fahlen.)

Three monuments that stand just inside the sentry gate at Naval Base Point Loma mark the sites of the village of La Playa, San Diego's first port, and La Playa Trail, the oldest European route along the Pacific Coast. Prior to 1769, native Kumeyaay lived here. Later, Spanish explorers under Cabrillo laid claim to Alta California. (Photograph by Kim Fahlen.)

In 1846, twenty-one men died at the Battle of San Pasqual in the Mexican-American War. Originally buried along a creek near San Pasqual, the bodies were reinterred in Old Town and again on Point Loma. On the right is a memorial to the Mormon Battalion, which made a 2,000-mile march to San Diego during the war. It reads: "Here lie Lydia Hunter and Pvt. Albert Dunham." (Photograph by Kim Fahlen.)

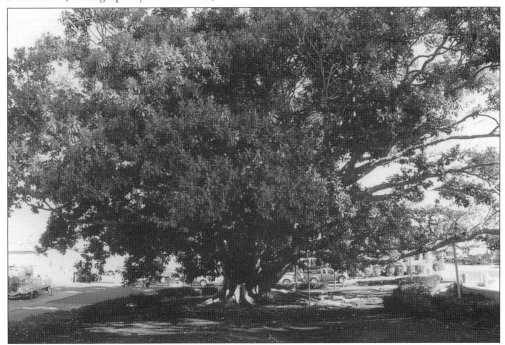

The Teddy Roosevelt Tree, located on the grounds of the former US quarantine station, was planted in 1908 by members of the San Diego horticultural community. The massive tree commemorates Arbor Day, established by Roosevelt on April 15, 1907. (Photograph by Charles Best.)

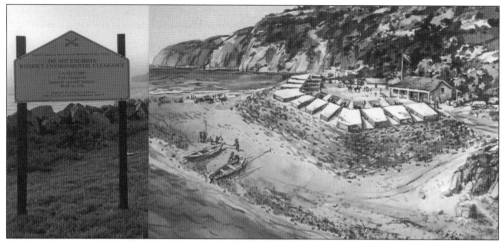

Marking the site of an outpost of Spain's far-flung empire was the first fortification in San Diego. This painting by Jay Wegter depicts the 1797 adobe Fort Guijarros, which boasted 10 gun emplacements and executed a single hostile action. A cannon fired upon American brig *Lelia Byrd* as her crew smuggled sea otter pelts. (Courtesy of the House of Spain, San Diego.)

Four monuments stand at the far end of Ballast Point. From left to right, the monuments commemorate the site of Juan Rodríguez Cabrillo's landing in 1542; the Johnson-Packard brothers' whale oil extracting site of 1857; the 1795 Fort Guijarros; and Fort Rosecrans, the post completed in 1904. (Photograph by Karen Scanlon.)

On July 21, 1905 the Navy gunboat USS *Bennington* lay at anchor on San Diego Bay when two boilers let loose, killing 65 sailors and one officer. Initially, 47 bodies were placed in a single large grave at the Army post cemetery. Men and officers of the Pacific Squadron formed Bennington Monument Association and erected a 60-foot granite obelisk to the memory of *Bennington*'s dead. Shown below are some of the 2,500 people who attended its dedication in January 1908. Funds were also raised in a community effort called Bennington Memorial Association, which paid for the handsome stonework around the burial site. This cover from a four-page program demonstrates civic rallying to raise donations. (Right, courtesy of the Naval History and Heritage Command; below, courtesy of SDHC.)

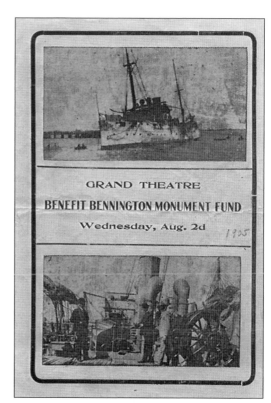

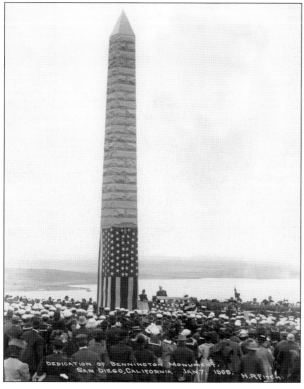

Originally called Albert G. Spaulding's Esplanade, today's Sunset Cliffs Natural Park was developed in 1915 by sporting goods magnate Albert Goodwill Spaulding. The Esplanade dovetailed with Balboa Park's Panama-California Exposition, the development of Loma Portal, and, ultimately, the Sunset Cliffs neighborhoods. (Courtesy of Charles Best.)

The Theosophical Society's Forestry Department (1910) was nestled on Point Loma's western flank overlooking Sunset Cliffs. Some 45,000 trees were planted on the point by the society's foresters. Pres. Theodore Roosevelt's chief forester, Gifford Pinchot, was a frequent visitor to the Homestead at Lomaland. (Courtesy of the Theosophical Society, Pasadena.)

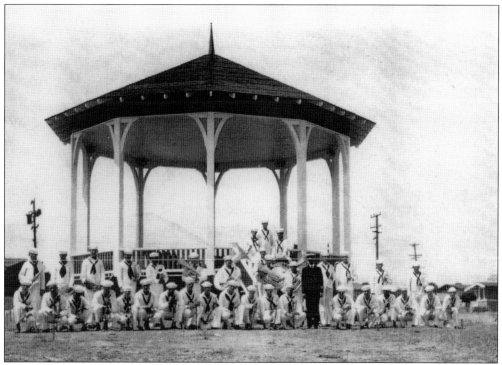

The Naval Training Station Bandstand, pictured around 1925, was situated slightly north of the officers' quarters along Rosecrans Street near the country club and golf course. Old-timers fondly remember regular Wednesday evening concerts by the US Navy Band. (SDHC.)

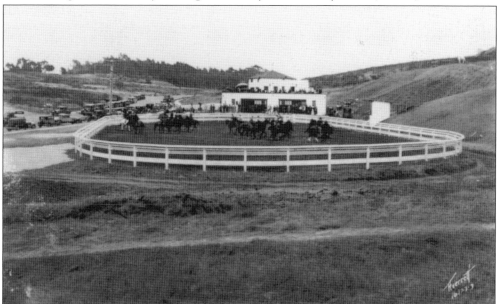

Point Loma Riding School, situated at Catalina Boulevard and Voltaire Street, was one of three stables that served the area in the 1930s. At that time, Point Loma High School boasted a girls' equestrian team, the Silver Spurs, which ranged all over Point Loma and Mission Valley in those halcyon days before the war. (SDHC.)

Sen. Leroy Wright officiates at the 1934 dedication of the original La Playa Trail marker at Roseville near Rosecrans and Byron Streets. The marker was destroyed in the early 1940s when Rosecrans Street was widened. In 2010, members of La Playa Trail Association dedicated a replacement Roseville marker at Union Bank near the corner of Rosecrans Street and Avenida de Portugal. Students from Cabrillo Elementary School took part in dedication ceremonies of both monuments. (Left, SDHC; below, photograph by Stuart Hartley.)

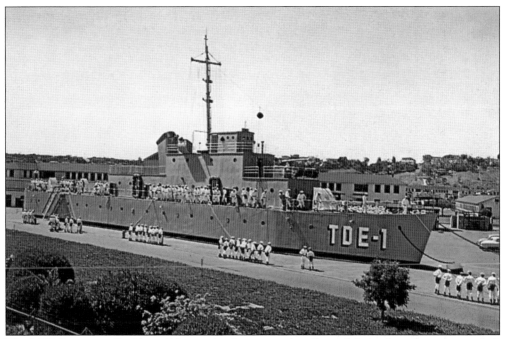

The USS *Recruit*, or Building 430, was the first in an elite fleet of three ships that never sailed. Dubbed "USS *Neversail*," she is not a ship at all, but a concrete and wood structure created to look like a ship. Classrooms for basic seamanship indoctrination filled her interior. On July 27, 1949, the non-ship destroyer escort was commissioned USS *Recruit* (TDE-1), and she was decommissioned in 1967. She was reconditioned in 1982 as an updated training guided missile frigate (TFFG-1) armed with three-inch wooden guns. The ship had been the training facility of 50,000 recruits annually but now seems oddly displaced in the redevelopment of Point Loma's distinguished Naval Training Center. (Above, courtesy of the NTC Foundation; below, courtesy of Kim Fahlen.)

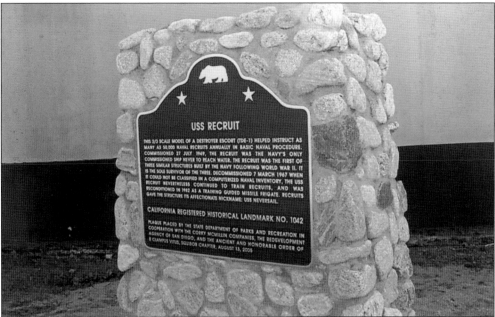

Citizens of Yokohama, Japan, presented the six-foot bronze Friendship Bell to San Diego to establish a sister-city relationship. Mayor Charles Dail dedicates the gift in 1960. The bell has no clapper but is struck with a wooden ram suspended by slings in the bell house. Only on New Year's Eve does the bell toll on Shelter Island. (Courtesy of the Japanese American Historical Society of San Diego.)

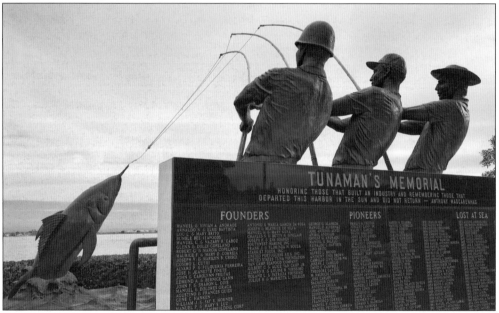

Generations of Portuguese immigrant fishermen skirted the then-unnamed Shelter Island shoal and stood offshore to await their turns to dock and unload at tuna canneries along La Playa. Dedicated in 1988, Tunamen's Memorial honors those who built an industry as well as fishermen lost at sea. (Photograph by Stuart Hartley.)

Artist James Hubbell's *Pearl of the Pacific*, dedicated in 1998, stands at the far end of Shelter Island. The dramatic Pearl Fountain, a large sphere set into the ground, is the third pearl in a necklace of Pacific Rim parks, commemorating friendship and cultural links among Pacific neighbors. Others are in Vladivostok, Russia; Tijuana, Mexico; and Yantai, China. (Photograph by Stuart Hartley.)

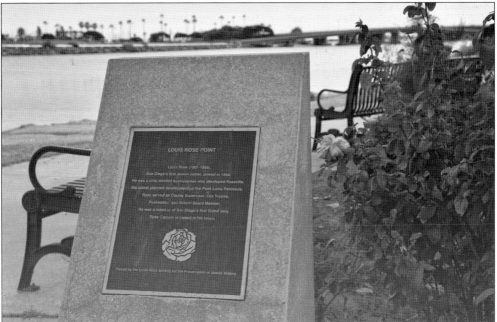

Louis Rose Point was dedicated at Liberty Station on March 24, 2011, the birthday of San Diego's first Jewish settler. Louis Rose was a civic-minded businessman who developed Roseville, the oldest planned community on Point Loma, in 1850. The Louis Rose Society for the Preservation of Jewish History erected the monument. (Photograph by Stuart Hartley.)

A monument to honor the Chinese fishing and shipbuilding industry was dedicated by La Playa Trail Association in 2012 at La Playa Cove. Ten shanties, drying racks, and salting tanks made up the village, and at the shore was a shipbuilding facility where Chinese junks were constructed using traditional design. Today, paths along the water's edge are popular with walkers and joggers. (Photograph by Stuart Hartley.)

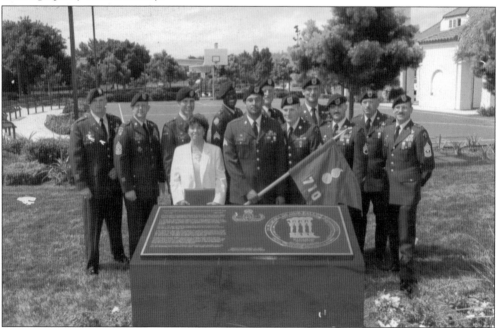

Dedicated in 2007 by historian Mary Ellen Cortellini and Drew Schunk of Lincoln Military Housing, a monument to soldiers of Fort Rosecrans stands at Liberty Station. In April 2002, an explosion in Afghanistan took the lives of three soldiers of the 710th Ordnance Company (EOD) from the former Fort Rosecrans and one Special Forces medic. (Courtesy of Mary Ellen Cortellini.)

A fitting tribute to former chairman of the Beautification Committee of Point Loma Association is the Hugh Story Monument and Rose Garden at Liberty Station. Story was also a prominent backer to the new Point Loma Hervey Library, a longtime submariner, and the force behind the 52 Boats Memorial. (Photograph by Stuart Hartley.)

Two long walkways at the expansive NTC Park honor submarines and crew lost in World War II. The 52 Boats Memorial recognizes the history of each boat and its losses on "Eternal Patrol." Planted among granite monuments are 52 American Liberty elm trees. A flag is placed on the date a submarine was lost. (Photograph by Jay Fahlen.)

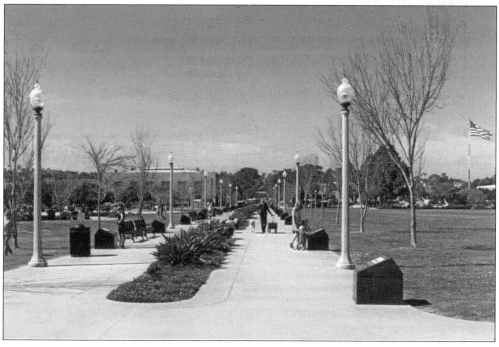

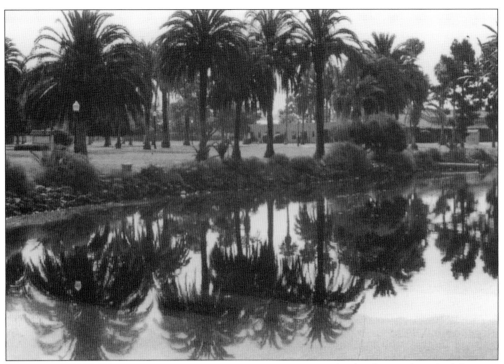

At the far north end of the small boat training channel at the former Naval Training Center lies a lagoon once used by recruits rowing whaleboats and gigs. Today, the lagoon is home to the Kanaka Outrigger Canoe Club and an adjacent native plant preserve. (Photograph by Charles Best.)

It's the end of the Trail at Point Loma: the last of six Trail markers was dedicated in 1934 and placed in the median on Rosecrans Street at Midway Drive. Young boys examine the logo showing an Indian vaquero and Mexican carreta. In 2010, members of La Playa Trail Association relocated the monument to the east side of Rosecrans Street. (SDHC.)

About La Playa Trail Association

If you live, work, or shop along the main thoroughfare in Point Loma known as Rosecrans Street, you traverse remnants of the oldest commercial route in the western United States. La Playa (the Beach) Trail ran from the landing spot of Juan Rodríguez Cabrillo and the Spanish Fort Guijarros on Ballast Point, along Rosecrans Street, and on east past Presidio Hill to the Mission San Diego de Alcalá.

In 2005, a group of Point Loma history devotees organized the nonprofit La Playa Trail Association. This group has carried on the work of early trailblazers who defined and marked historic sites along the trail. Efforts of members include moving, reconstructing, and rededicating historic markers along La Playa Trail.

La Playa Trail Association has also become known for its bimonthly history lecture series, presented at the historic Point Loma Assembly building on Talbot Street in Point Loma.

DISCOVER THOUSANDS OF LOCAL HISTORY BOOKS
FEATURING MILLIONS OF VINTAGE IMAGES

Arcadia Publishing, the leading local history publisher in the United States, is committed to making history accessible and meaningful through publishing books that celebrate and preserve the heritage of America's people and places.

Find more books like this at
www.arcadiapublishing.com

Search for your hometown history, your old stomping grounds, and even your favorite sports team.